IMAGES
of America

KINGSTON

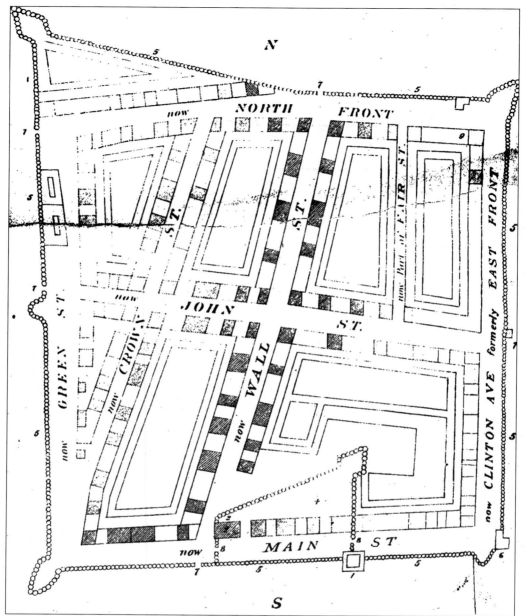

STOCKADE MAP C. 1695. The Reverend John Miller drew this map from memory in 1695. While on a voyage back to England, pirates beset Miller's boat and all his notes were lost. When he arrived in port, Miller re-created this map of Wiltwyck, which depicts the settlement within the stockade walls that had been built at the direction of Petrus Stuyvesant to protect the inhabitants from possible intrusion. The streets of uptown Kingston today preserve the pattern shown on this 17th-century map.

IMAGES
of America

KINGSTON

Edwin Millard Ford with Friends of Historic Kingston

ARCADIA

First published 2004
Reprinted 2004

Published by Arcadia Publishing,
Charleston SC, Chicago IL, Portsmouth NH, San Francisco CA

Printed in Great Britain

Library of Congress Catalog Card Number: 2004108750

For all general information, contact Arcadia Publishing:
Telephone 843-853-2070
Fax 843-853-0044
E-mail sales@arcadiapublishing.com
For customer service and orders:
Toll-free 1-888-313-2665

Visit us on the Internet at www.arcadiapublishing.com

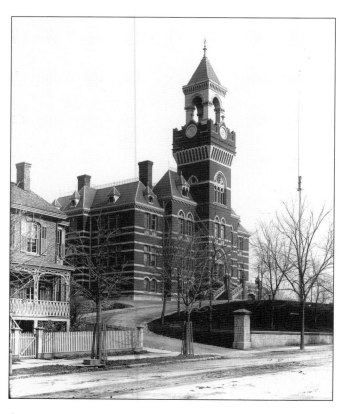

CITY HALL C. 1900, 420 BROADWAY. Kingston City Hall stands at 420 Broadway.

CONTENTS

ACKNOWLEDGMENTS

The photographs in this book are primarily from the archives of the Friends of Historic Kingston, including the Herman Boyle Collection and the Edwin and Ruth Ford Collection. In addition, we relied upon the generous assistance of Robert A. Slater, Marilyn Beichert Powers, and the family of William J. O'Reilly.

We would also like to thank the following: Dolorita McCabe, Susan Hummel, Donna Light, Ron Woods, Roger Mabie, Seward Osburne, Florence Prehn, Joyce Carey, Hugh Reynolds, Matilda Davenport, Herbert Shultz, Ray Caddy, William B. Rhoads, David Wheatcroft Antiques, the family of Thomas Miller, and the family of Adam and Emily Salzmann. This project would not have been possible without the guidance of Patricia Murphy and Jane Kellar. Thanks also to the board of directors, and the entire membership of this fine organization, Friends of Historic Kingston.

Finally, we would like to pay special tribute to those early photographers who preserved our visual history with their camera lenses and to all the individuals who have saved these wonderful documents over the years.

—Edwin Millard Ford and Friends of Historic Kingston, 2004

INTRODUCTION

The seeds of the city of Kingston were planted when five families left the Rensselaerwyck Patroon—the area of present-day Albany, New York—and came here to farm their own land in 1652. They formed a scattered settlement on the northwest edge of the present city on the fertile flood plain bordering the Esopus Creek, where a band of the Algonquian Nation, the Esopus Indians, had their maize fields. Farming side by side led to disputes that eventually brought the two groups to the brink of war.

In 1658, Peter Stuyvesant, director-general of the New Netherlands Colony, ordered the Kingston settlers to move to a central location and surround it with a stockade. He selected the site, a bluff whose height on three sides afforded natural protection and, within three weeks, the settlers built a 14-foot-high stockade, constructed from 8-inch-diameter trees, to enclose the settlement. The settlers moved their log houses and barns from the lowlands to the confines of the fortified village that Stuyvesant had named Wiltwyck. Today, with the original street plan still intact and having survived two torchings, that settlement forms the uptown business district of Kingston.

The village was burned on June 6, 1663, by the Esopus Indians and on October 16, 1777, by British troops during the period when Kingston was serving as New York State's first capital. Today, the Stockade District is a National Historic District where many of the limestone houses built by the colonists still stand, including the Abraham Van Gaasbeek House, where New York State's first elected senate held meetings in 1777. George Clinton, New York's first elected governor, is buried in the Old Dutch Church graveyard side by side with descendants of some of Kingston's earliest settlers and Revolutionary War soldiers. Also located within the Stockade District is the courthouse site where the New York State constitution was written in 1777.

Bordering the Rondout Creek, the downtown area of Kingston developed as a separate village called Rondout. One of only three deep-water ports along the Hudson River, Rondout was the scene of maritime activity beginning in the early 17th century, when the Dutch set up trading posts on the Hudson. In the 19th century, the village population exploded following the opening in 1828 of the Delaware and Hudson Canal, the eastern terminus of which was at Rondout. Waves of immigrants, mostly Irish and German, poured in, seeking jobs on the canal and in allied businesses such as boat building, brick making, and cement mining. In 1849, Rondout was incorporated as a village, and by 1855, with 6,000 residents, it surpassed the uptown village of Kingston in population. Rondout reached its peak of prosperity in 1870, when three million tons of coal were shipped on the canal.

In 1871, Rondout officials petitioned the state government in Albany to designate their burgeoning village as a city, but Kingston's leaders, fearing that the more populous Rondout might upstage their own community, proposed that the two villages unite instead. And so, on May 29, 1872, the two villages together were incorporated as one city, called Kingston. Land located between the two villages (now midtown) was selected as the site on which to build the city hall, an Italianate Gothic building that opened in 1875 and still serves as the seat of local government.

In 1873, the tracks of the Wallkill Valley Railroad reached Kingston, cutting through the city's center. Factories for manufacturing a variety of goods—ranging from lace to cigars and can openers—sprouted around the railroad station. Midtown developed into the city's industrial heartland. Shirt and dress factories were the most numerous, and many continued to operate into the 1960s.

But, the rise of rail transportation in the second half of the 19th century led to a decrease in canal traffic and the closing of the Delaware and Hudson Canal in 1898. With the canal's closure, the fortunes of Rondout fell, ushering in a decline of the waterfront area over the next 60 years. Over time, boatyards and shops shut down. And in the 1960s, urban renewal forced most of the population to move out of the Rondout area.

In the late 20th century, Rondout's downslide has been reversed; there has been an upturn in the local economy spurred by entrepreneurs, city efforts, and public funding. The waterfront again bustles with activity. In place of the boatyards where tugs and barges were built many years ago, there are now marinas filled with pleasure boats lining the Rondout Creek. Today, Kingston is a port of call for many cruise ships. Upscale restaurants, art galleries, and boutiques fill the storefronts that were once occupied by first- and second-generation immigrants.

Kingston's uptown business district, a victim of the flight of retail businesses to the malls in recent decades, has undergone a similar evolution. One of the most significant changes in the city's character is the presence of a growing art community. Former factory spaces are being used as studios, and galleries are a major attraction for visitors.

In 1982, in recognition of its role as a major transportation center, Kingston was designated as one of the first Urban Cultural Parks (now called Heritage Areas) in New York State. Kingston has four historic districts on the state and national registers. The city's current population is approximately 23,000.

One
LEGACY IN STONE

PIETER CORNELIUS LOUW HOUSE C. 1922, 1 FROG ALLEY. One of the earliest recorded houses in Kingston, it is constructed of native limestone, the material used in all of the stone houses throughout Ulster County. When it was slated for demolition by the Kingston Urban Renewal Agency, the property was purchased by Friends of Historic Kingston in 1972, and the foundation ruins and land have been preserved as a park.

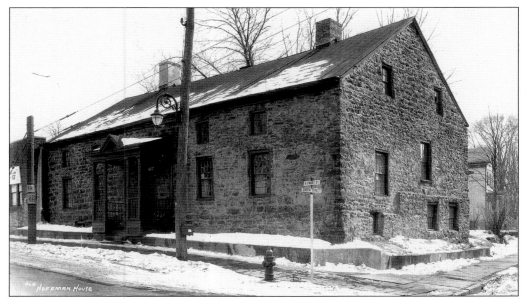

ANTHONY HOFFMAN HOUSE C. 1920, 96 NORTH FRONT STREET. It is believed this may have been a fortified house because it is strategically placed on the southwest corner of the Stockade, at the western gate. A staircase and an opening in the roof apparently were used as a lookout. Nine generations of the Hoffman family lived here from 1707 until 1910, after which time the house was bought by the Salvation Army, which used it as local chapter headquarters for over 50 years. Today it is a popular tavern.

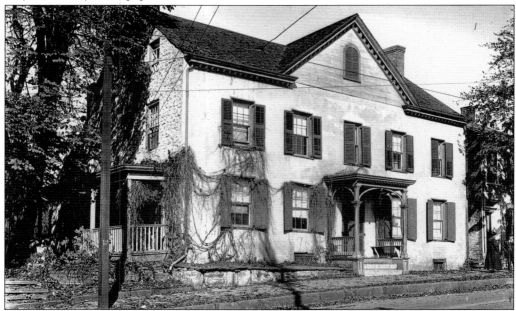

JOSEPH GASHERIE HOUSE C. 1920, 93 NORTH FRONT STREET. Located across from the Hoffman House, this home was demolished in the early 1900s, soon after this photograph was taken. Gasherie was appointed the first Surrogate Judge of Ulster County in 1766. The family of Edward O'Neil, founder of the Methodist Church in Kingston, later occupied the house.

DeWall Tavern c. 1880, North Front Street. Home of Willem DeWall, this house was noted for its second-story dance floor, where many local balls were held in the late 18th century. During urban renewal in the 1960s, the structure was demolished to make room for a parking lot.

Col. Jacobus Bruyn House c. 1900, 67 North Front Street. Colonel Bruyn served in the Revolutionary War under Gen. George Clinton. After Bruyn was captured by the British at Fort Montgomery, he was confined on a prison ship for three years. In the early 20th century the building was occupied for many years by Schwartz's Second Hand Store. The house was destroyed in the 1960s and the site is now the Peace Park.

SENATE HOUSE C. 1880 BEFORE RESTORATION, 331 CLINTON AVENUE. The home of Abraham Van Gaasbeek was the meeting site of the newly formed New York Senate. On September 20, 1777, the final vote was taken here to adopt the New York State constitution. The frame additions were removed by New York State following the acquisition of the house in 1888 to serve as an early museum portraying our state history.

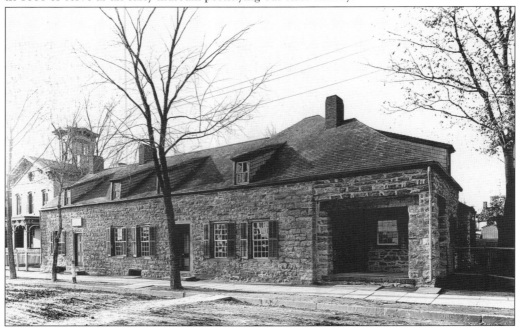

SENATE HOUSE C. 1890 AFTER RESTORATION, 331 CLINTON AVENUE. One of the earliest state historic sites, the building and its contents interpret the home of the Van Gaasbeek family who lived here during the Revolutionary War. The senate room is restored today as it might have looked when the representatives of the provincial congress met in Kingston in the fall of 1777.

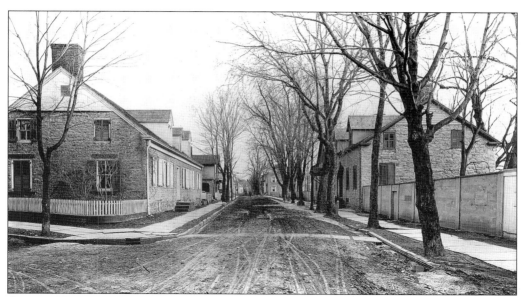

GERRET VAN KEUREN HOUSE C. 1880, 138 GREEN STREET. The construction of this house (on the left side of the street in this photograph) began as early as 1710, according to the deed. Charred wooden beams in the basement date to the burning of Kingston by the British on October 16, 1777. The house was restored in the early 1920s by the Colonial Revival architect Myron Teller.

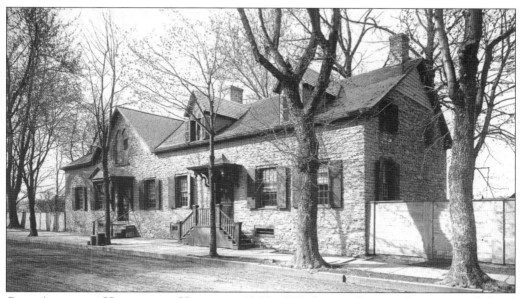

COL. ABRAHAM HASBROUCK HOUSE C. 1880, 135 GREEN STREET. Lieutenant Colonel Hasbrouck served during the Revolution with the Northern Militia of Ulster County. He and his family lived here from 1735 until 1776, when the house was badly burned by a fire that started in the attic and also spread to six neighboring houses. The Hasbrouck House was rebuilt, but one year later it burned again when the British torched the whole community.

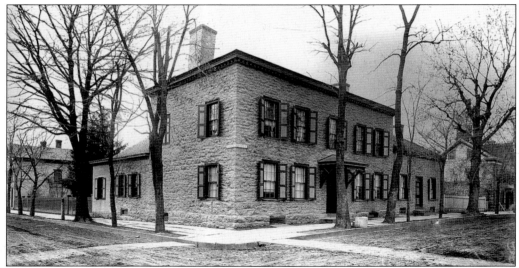

Dr. Matthew Jansen House c. 1880, 43 Crown Street. Restored following the British burning of Kingston, the current building retains a portion of the original structure. Dr. Matthew Jansen occupied the home for many years. He was a general practitioner who saw patients in the adjoining stone building. This group of four buildings of native limestone was built prior to the Revolutionary War and is called the Four Corners.

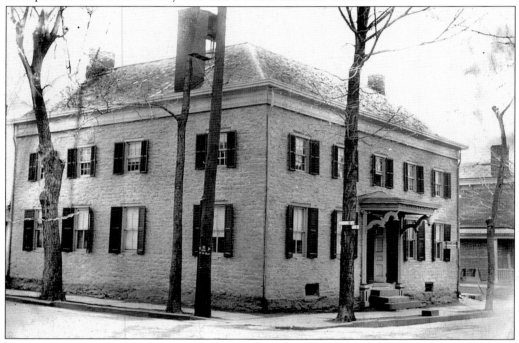

Kingston Academy c. 1880, 35 Crown Street. Built in 1774 as a private academy, students came from all over New York State to study here. Early on, students were required to speak in Latin during the school day. A Kingston newspaper, the *Daily Leader*, bought the structure in 1913. The building has served as the site of various commercial enterprises, including a Sears Roebuck store and a series of restaurants.

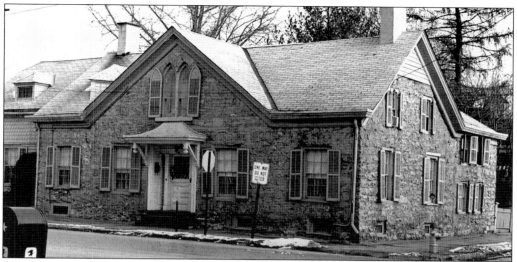

FRANZ ROGGEN HOUSE C. 1970, 42 CROWN STREET. Built by a Swiss family and occupied by their descendants for over 200 years, this house was adapted for commercial use in the mid-20th century.

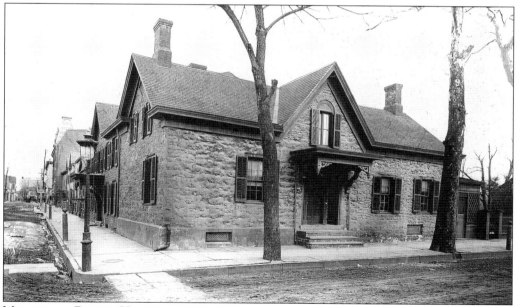

MATTHEWIS PERSEN HOUSE C. 1880, 74 JOHN STREET. Recent archaeological investigations have shown this to be the site of a structure that existed as early as 1663. The house was burned by the Esopus Tribe of the Delaware Nation in 1663 during the Second Esopus War, and burned again by the British on October 16, 1777. The building was purchased by Ulster County in the early 20th century and was restored in the early 21st century.

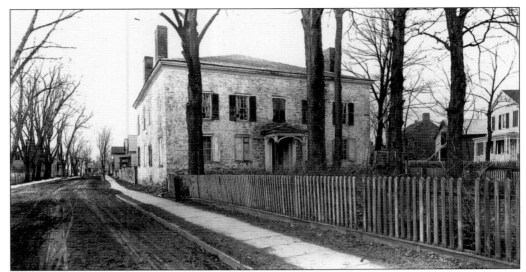

HENRY SLEIGHT HOUSE C. 1880, GREEN AND CROWN STREETS. This building was slated for demolition in 1905 and was rescued by the Wiltwyck chapter of the Daughters of the American Revolution for use as its headquarters. Noted Colonial Revival architect Myron Teller restored the structure in 1907 at the chapter's request.

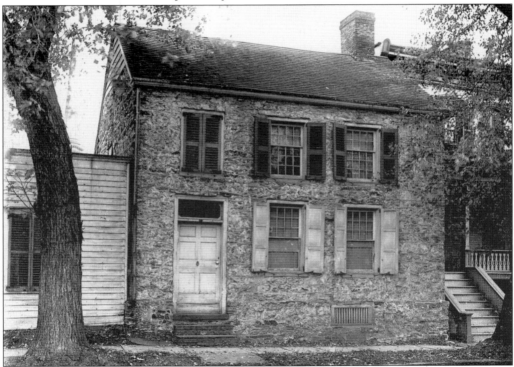

CHRISTOPHER TAPPEN HOUSE C. 1880, 10 CROWN STREET. Known as the first post office for Kingston, this was the home of the deputy county clerk, Christopher Tappen, from 1777 to 1825. His sister Cornelia was married to George Clinton, who held the title of county clerk for over 50 years while his brother-in-law Tappen carried out the actual duties.

16

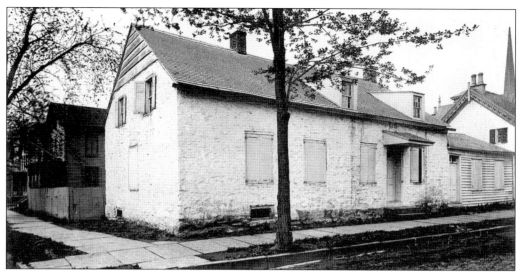

Dr. Peter Vanderlyn House c. 1880, 85 Main Street. This Dutch vernacular house, made of limestone, was at the corner of Main and Green Streets. Vanderlyn's father, also named Peter Vanderlyn, was an artist who arrived in this country at the beginning of the 18th century, and married the daughter of the Dominie Petrus Vas of the Dutch Reformed Church. His nephew was the artist John Vanderlyn.

Demolition of Dr. Peter Vanderlyn House c. 1890, 85 Main Street. This unusual photograph documents the demolition of the Vanderlyn home in the late 19th century. A brick Victorian townhouse that serves today as law offices was built in its place. The Henry Sleight house is visible down the street.

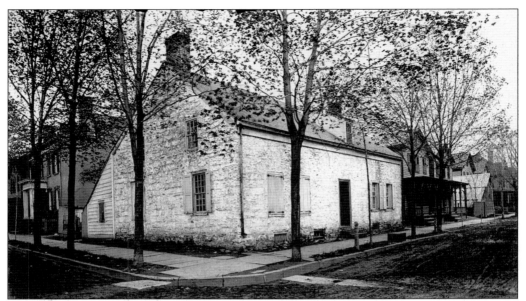

DAVID DELAMETER HOUSE C. 1880, CORNER OF MAIN STREET AND GREEN STREET. This limestone house was destroyed in the late 19th century. The Delameter family was in Kingston as early as 1726, according to the records of the Old Dutch Church.

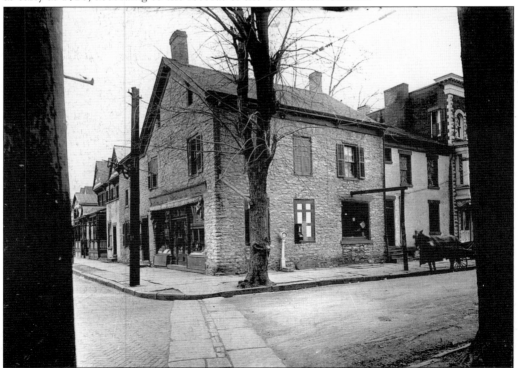

DR. CORNELIUS ELMENDORF HOUSE C. 1880, 255 WALL STREET. The stone house on the corner of Main Street was converted to commercial uses during the 19th century. In the 20th century it was the site of Everett's Bakery and later was used for insurance and law offices.

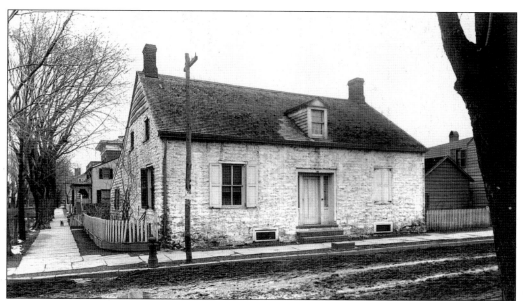

TEUNIS SWART HOUSE C. 1880, SOUTHEAST CORNER OF PEARL AND WALL STREETS. This limestone house was destroyed in the late 19th century. It was replaced by a corner storefront building of brick.

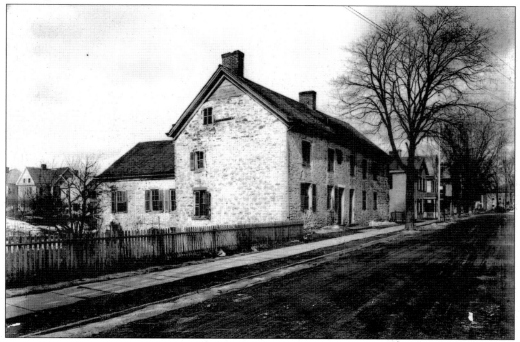

COL. DIRCK WYNKOOP HOUSE C. 1880, GREEN STREET. This stone house, demolished in the 1920s, was located in the block between Pearl and Main Streets on the west side of Green Street. George Washington dined with Colonel Wynkoop here in November of 1782. At the time, Washington was on a trip through the Upper Hudson Valley, during which he thanked his followers for their support.

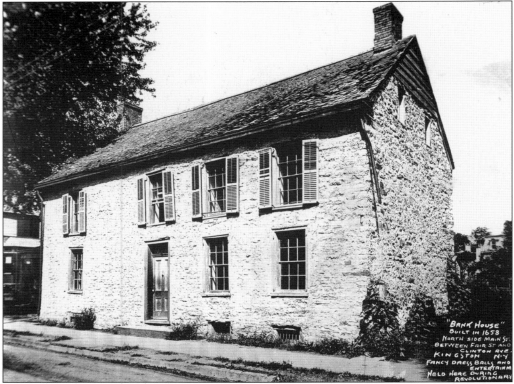

BANK HOUSE C. 1880, MAIN STREET. Located at the head of Main Street near Clinton Avenue, the stone house was destroyed in the late 19th century. It was a branch of the Middle District Bank and the home of banker Severyn Bruyn.

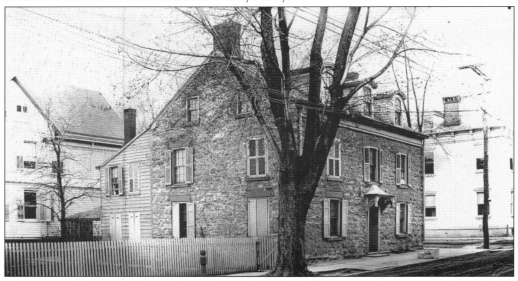

ELMENDORF TAVERN C. 1908, 88 MAIDEN LANE. This house was the meeting place for the Council of Safety at the time of the Revolution. The council was appointed by the New York Convention in February 1777 to provide for the safety of public property and records.

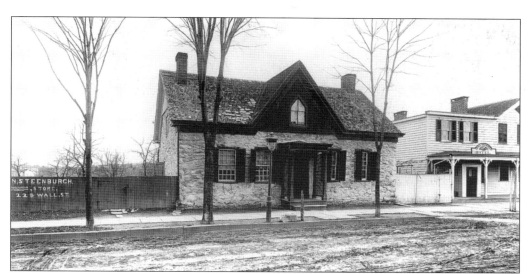

TOBIAS VAN STEENBURGH HOUSE C. 1880, 97 WALL STREET. This is reputed to be the only house in Kingston that was not burned by the British on October 16, 1777. The first town meeting following the fire was held at the house in March 1778. The structure today retains early–18th century details, including the twelve-over-twelve-pane windows, panel shutters, and hardware.

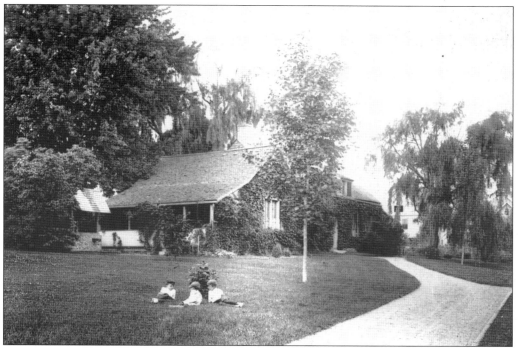

CORNELIUS MASTEN HOUSE C. 1900, 109 PEARL STREET. Born in 1703, Cornelius Masten, at age 47, married Catharina Van Steenburgh and they set up residence here with their six children. Masten was a constable, a village trustee, and magistrate in 1749. During the 1777 burning of Kingston, he suffered severe losses to this house and barn. Masten died in 1787. In 1893 the house was bought by Julia Dillon, artist.

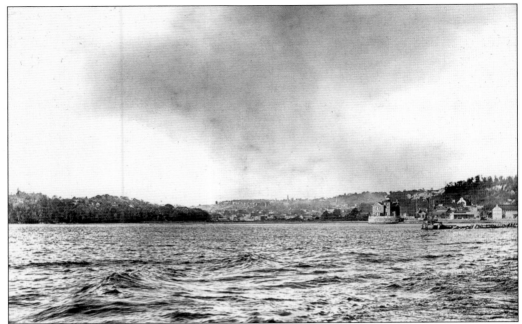

RONDOUT CREEK C. 1880. Rondout Harbor was the largest shipping center in the Mid-Hudson Valley at the time this photograph was taken. The first Kingston lighthouse was built in 1867 and was abandoned in 1913 for the new light. The Newark Lime and Cement Company is on the right, and the rooftops and church spires of the village of Rondout are visible in the distance.

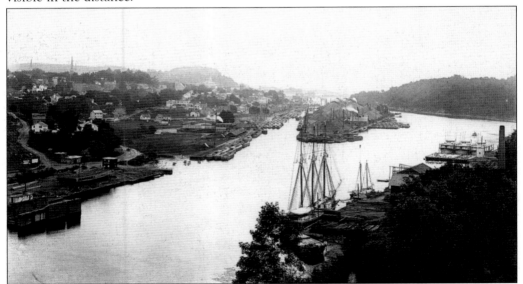

ISLAND DOCK FROM WEST SHORE RAILROAD BRIDGE C. 1885. Tons of coal shipped from Pennsylvania to Rondout on the Delaware and Hudson Canal are piled and awaiting shipment to market. Canal boats of the Delaware and Hudson Canal Company are tied along the pier. On the left is J. and J. McCausland's shipyard, which built barges and advertised a floating dry dock.

Two
MARITIME HISTORY

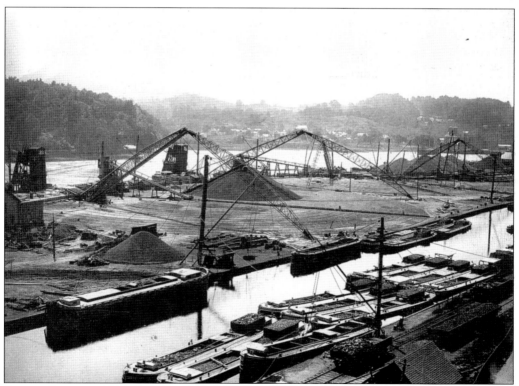

ISLAND DOCK C. 1892. Rondout was the eastern terminus of the Delaware and Hudson Canal. Opened in1828, the 108-mile canal carried anthracite coal from Honesdale, Pennsylvania, to Rondout. The canal had 107 locks to raise and lower vessels on the waterway.

DELAWARE AND HUDSON CANAL COMPANY MAIN OFFICE C. 1900. Overlooking Island Dock, the company's office building was built in the 1840s. Constructed of local bluestone, the three-story structure dominated the area until 1898, when the canal company ceased operations. The building was demolished in 1938. A path from Dock Street to Abeel Street still exists at this site, along with a recently constructed lookout erected on the office building's foundation.

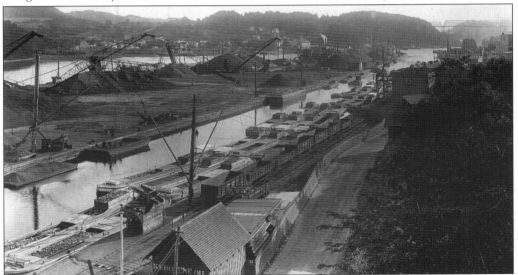

ISLAND DOCK C. 1900. After nearly 20 years of storing coal below Abeel Street on the bank of the Rondout Creek, a larger transfer storage facility was needed. In 1847, local engineer James S. McEntee designed an island that would be built over the mud flats in the Rondout Creek by driving pilings down to the bedrock. Tons of fill created the first pile dock ever constructed in America.

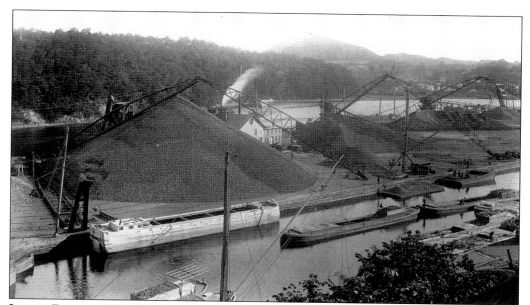

ISLAND DOCK C. 1900. The larger canal boat in the foreground carried coal cargo on the Hudson River. The Dodge Yarding System, an assemblage of unloading elevators installed in 1890, was able to handle 1,000 tons a day and automatically weighed and screened the cargo at the same time. This was a vast improvement from the days of men with wheelbarrows doing the work.

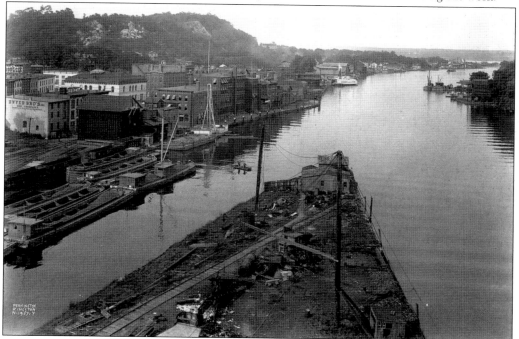

ISLAND DOCK C. 1927. Island Dock began to be used for shipbuilding c. 1900. John D. Schoonmaker Sr. turned from his lucrative ice business to form the Kingston Dry Dock and Construction Company, which built dry docks, barges, lighters, tug boats, and dredges. The company built two oceangoing cargo vessels and a marine railway in 1918.

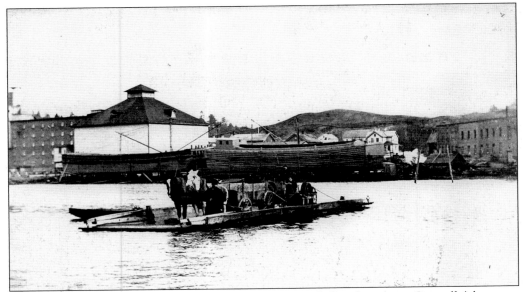

SOUTH RONDOUT FERRY C. 1900. Ferry service in South Rondout (now Connelly) began as early as the 1820s, transporting passengers across the Rondout Creek to Fischer's Dock, located near the foot of Hudson and Abeel Streets in Kingston. The scow was piloted by an operator who used a pole to propel the boat. The load limit was two horses and a wagon. The ferry ceased operations several years before the Port Ewen Bridge was built in 1922.

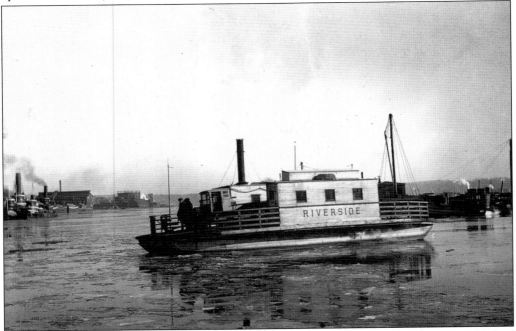

FERRY RIVERSIDE C. 1900. Ferry service between Rondout and Sleightsburgh was established c. 1850 by descendants of John P. Sleight. A chain resting on the bottom of the Rondout Creek passed through the ferry's machinery to provide propulsion. A complete description and history of the ferry is provided in *The Old Skillypot* by Glendon Moffett.

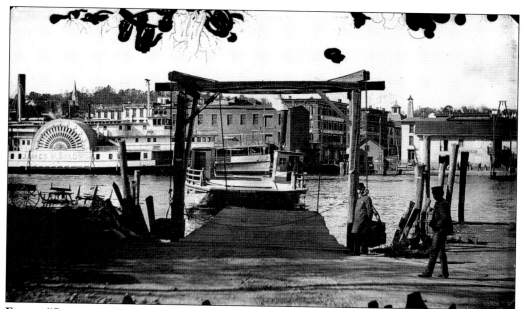

FERRY "SKILLYPOT" C. 1880. The *Riverside* ferry was nicknamed the "Skillypot," a Dutch word meaning turtle. Was this because of its appearance, or its pace? The ferry was also affectionately referred to as "The Other Side" because that is where it always was when you needed service. This writer remembers long lines of autos waiting on the Sleightsburgh Hill to be transported across the creek.

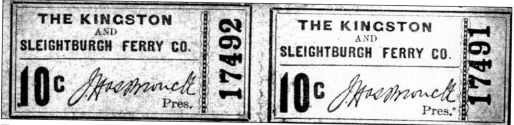

TICKET FOR KINGSTON AND SLEIGHTBURGH [SIC] FERRY CO. C. 1909. This 10¢ ferry ticket bears the name "J. Hasbrouck, Pres." Dr. Josiah Hasbrouck purchased the ferry company in 1909, and his estate continued its operation until 1922, when the Kingston-Port Ewen Bridge was built. Hasbrouck was a physician and benefactor of the Connelly Fire Department, which named its company the Hasbrouck Engine Company in his honor.

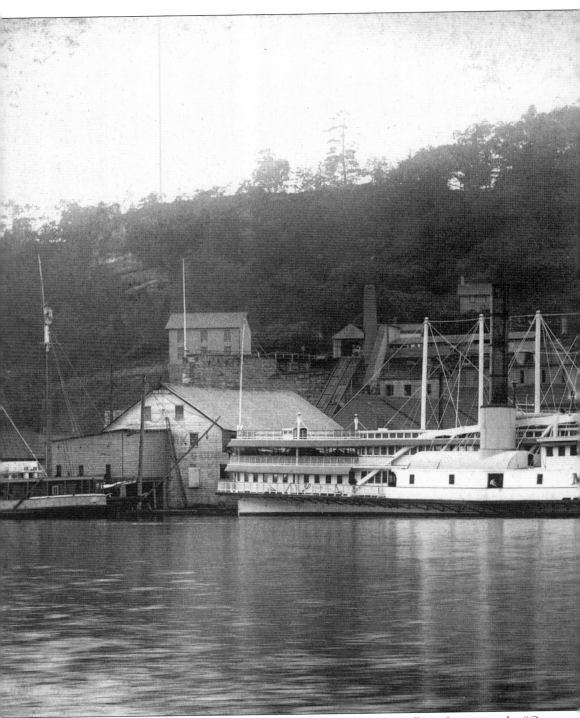

STEAMBOAT MARY POWELL C. 1880. The steamboat *Mary Powell* was known as the "Queen of the Hudson." Owned by Capt. Absalom Lent Anderson, the day boat ran between Rondout and New York City for half a century. Built in 1861 in New Jersey, she was noted for her perfect

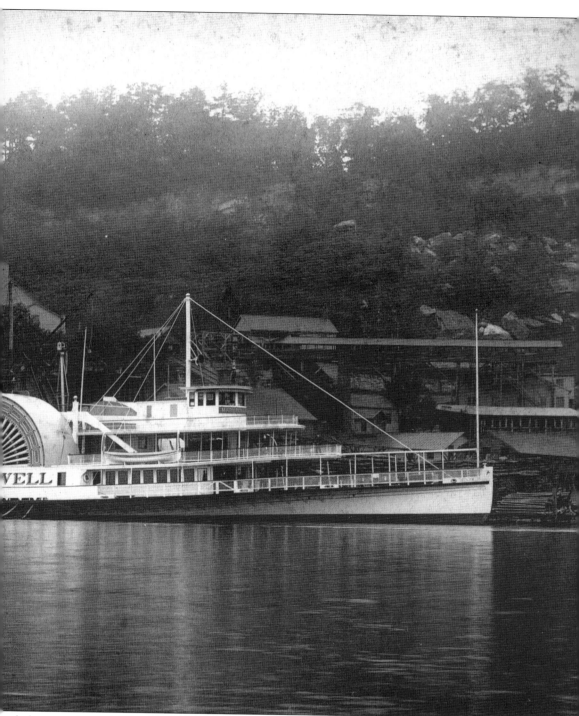

balance and speed. The crew joked that one of them was assigned to shoo the flies off the deck so they wouldn't unbalance the boat. The *Mary Powell* was officially abandoned in 1920 but her legend continues to this day.

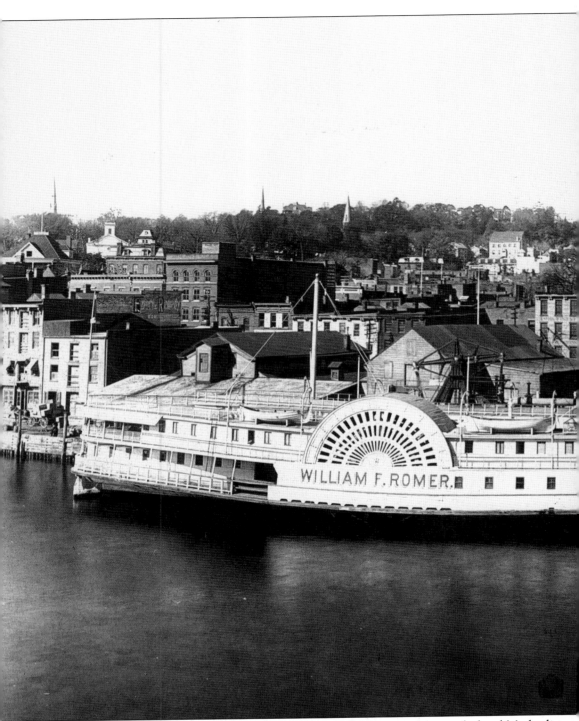

STEAMBOAT *WILLIAM F. ROMER* C. 1911. William F. Romer was the son of a local Methodist minister. He married Jane Baldwin, the daughter of James W. Baldwin, a prominent citizen in Kingston. After pursuing a financial career, Romer moved into shipping and founded the

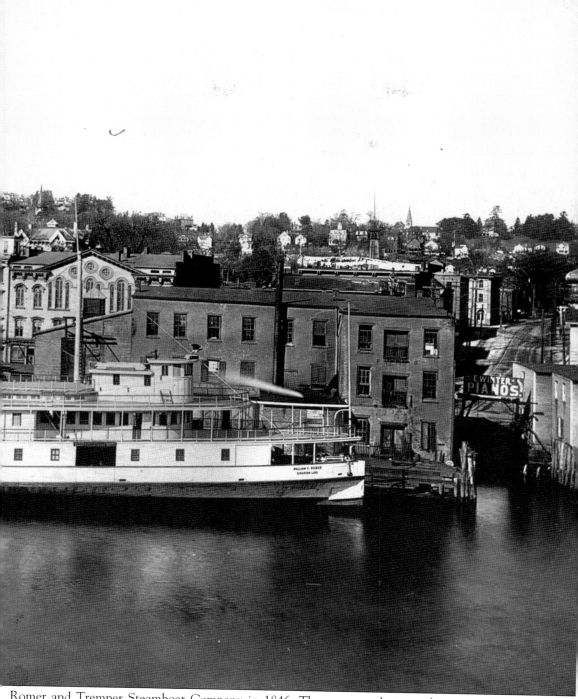

Romer and Tremper Steamboat Company in 1846. The company became the owner of the Albany and Newburgh Day Line and operated the steamboats *William F. Romer*, *James W. Baldwin*, *M. Martin*, and *The City of Kingston* out of the Rondout Creek.

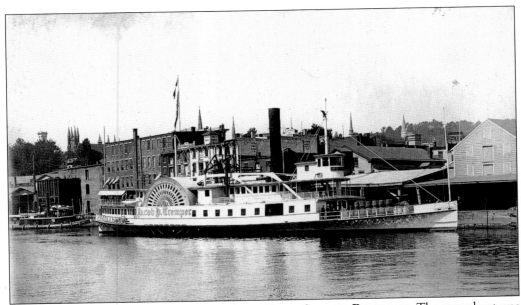

STEAMBOAT JACOB H. TREMPER C. 1900, AT FERRY STREET, RONDOUT. The steamboat was named for Capt. Jacob H. Tremper, William Romer's business partner in the Romer and Tremper Steamboat Company. Romer died in 1884, and Tremper passed away in 1888. Tremper's son, Jacob Jr., then joined with local businessman Myron Teller to operate the company. Tremper later entered politics, was elected to the New York State Assembly in 1898, and owned and operated the Tremper House hotel in Phoenicia.

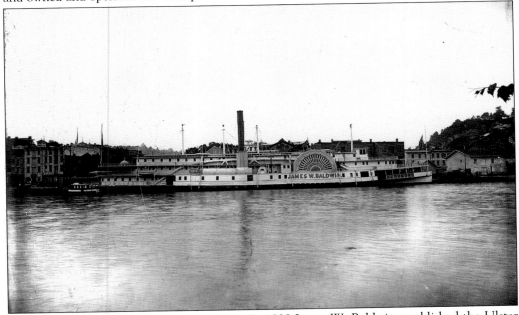

STEAMBOAT JAMES W. BALDWIN C. 1900. In 1830 James W. Baldwin established the Ulster Foundry on the corner of St. James and Prospect Streets. The steamboat named for him was built in Jersey City, New Jersey, in 1860, and for a time, Capt. Jacob H. Tremper took personal command of the boat, which was the largest of the New York night-line steamers.

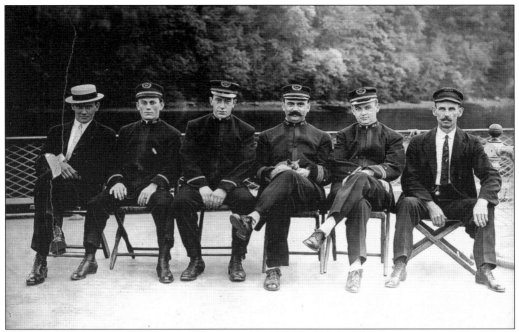

CREW OF STEAMBOAT *WILLIAM F. ROMER* C. 1911. The men shown in this photograph taken aboard the boat in the Rondout Creek include Capt. Fred L. Simpson, Second Pilot Henry Metcalf (father-in-law of Richard Heffernan), the purser, and unidentified crew members.

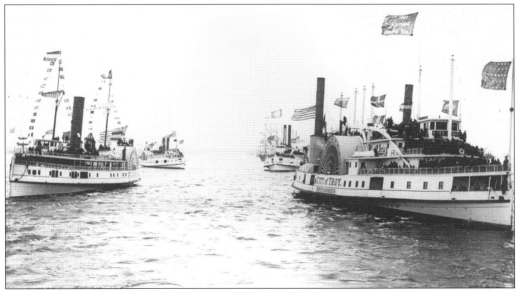

STEAMBOATS ENTERING THE HARBOR C. 1880. The *City of Troy* leads a flotilla of steamboats entering the Rondout Creek in this photograph of a now-forgotten occasion. In 1884, the *City of Troy* was the cause of an infamous accident with the *Mary Powell* in the waters near Hyde Park. The incident gained notoriety not because the *Troy* sank that day, but more so because the collision delayed the famously punctual *Powell*'s arrival in Rondout until after 10:00 p.m.

CORNELL STEAMBOAT SHOPS C. 1912. In 1836 Thomas Cornell purchased property in Eddyville along the towpath of the Delaware and Hudson Canal. Cornell soon realized that the towing and tugboat business was more profitable than passenger service, so he established the Cornell Steamboat Company. The business prospered, eventually requiring large repair facilities that led to the construction of the boiler shop and repair shop about 1890 and 1900, respectively.

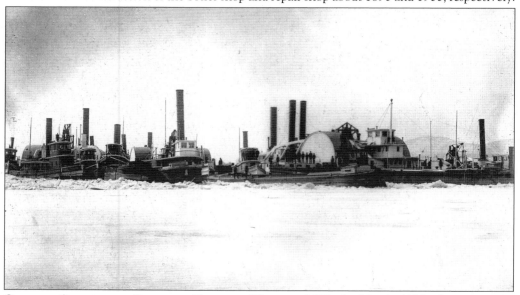

CORNELL STEAMBOAT COMPANY TUGS IN WINTER, 1893. In March 1893, the ice in the Rondout Creek suddenly gave way, resulting in an ice jam that swept many of the Cornell Steamboat Company's tugs down to the mouth of the creek. The tug *Rob* was sunk and 17 more tugs were damaged. Island Dock was flooded, and Abeel Street was choked with huge chunks of ice, extending from the railroad bridge to Davis Street. The Hiltebrandt Dry Dock was washed out.

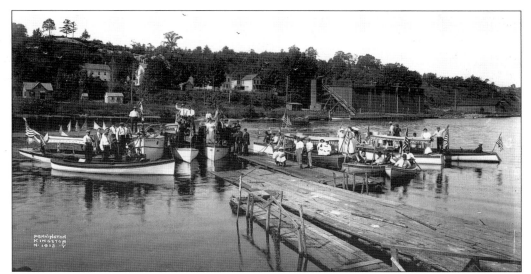

NAPHTA BOATS C. 1912. A naphta launch was an open pleasure boat that was propelled by using a naphta solvent—a distillation of petroleum—for fuel. One boat named the *Red Monogram* was owned by George Hauck and Sons Brewing Company, which manufactured beer under the Red Monogram label.

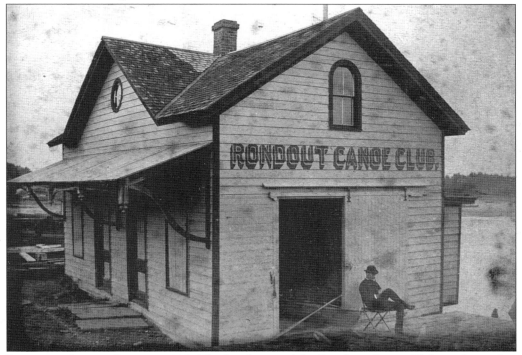

RONDOUT CANOE CLUB C. 1885. The boathouse of the Rondout Canoe Club was located at Powell's Dock, Ponckhockie. The club was organized January 22, 1884, with the following officers listed in 1885: Commodore Henry S. Crispell, a Freeman employee; Vice-Commodore Charles V. A. Decker; and Secretary/Treasurer Guilford Hasbrouck, a partner in Hasbrouck and Alliger Boot and Shoe Dealers.

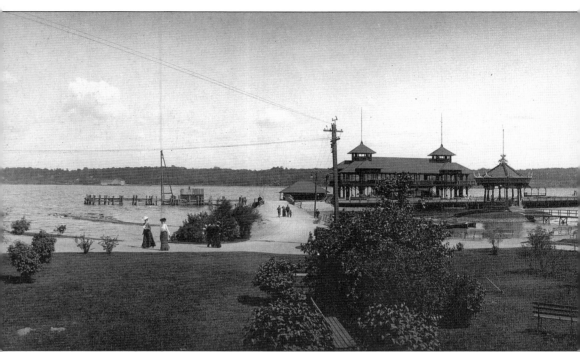

KINGSTON POINT PARK C. 1900. In 1896 Samuel Coykendall and his wife, Mary Augusta, purchased Kingston Point from the Delaware and Hudson Canal Company. The Coykendalls

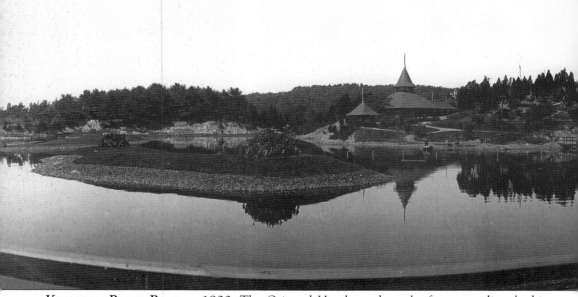

KINGSTON POINT PARK C. 1900. The Oriental Hotel stood nearby for guests disembarking from the day liners. Amusement features at Kingston Point Park included a carousel, penny arcade, bowling alley, bandstand, shooting gallery, refreshment stands, a Ferris wheel, rowboats for hire, canoes, a dance hall, and a theater with a 900-person seating capacity and a 30-by-40-foot stage. One of the most popular features at Kingston Point Park was the carousel. Two of

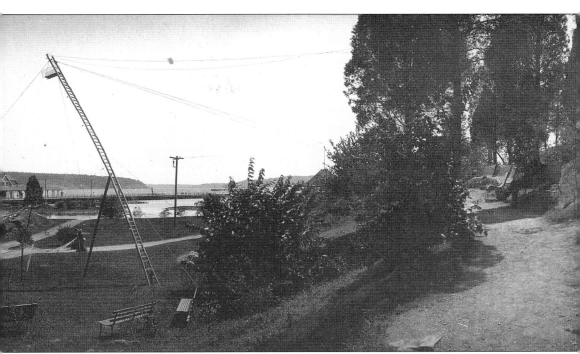

hired noted landscape architect Downing Vaux to design the park with winding walks, gazebos, shrubbery, gardens, lagoons, and a bridge.

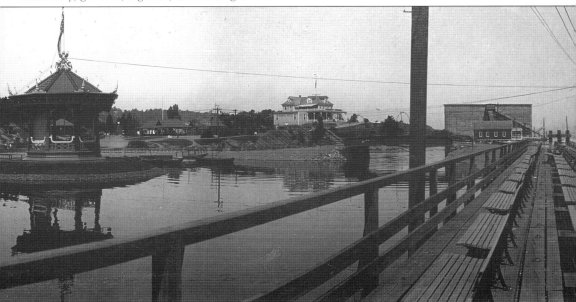

the carousel horses were named for popular Spanish-American War generals William Shafter and Nelson Miles. In 1898 General Shafter was placed in command of the U.S. Army forces that invaded Cuba and led the capture of San Juan and Santiago. General Miles brought reinforcements to Cuba and accepted the surrender that ended the war.

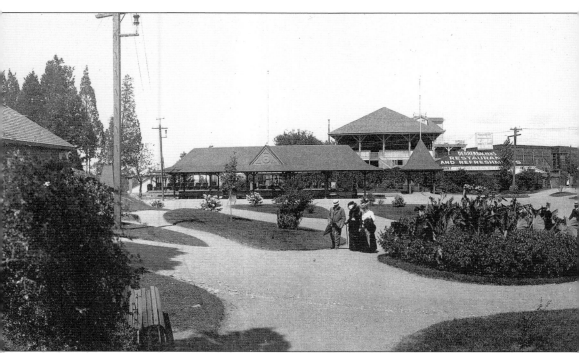

KINGSTON POINT PARK C. 1900. The site of this popular tourist attraction held an important place in our history. The United New Netherland Company of Amsterdam had agents in the Hudson Valley as early as 1614 to trade for furs with the natives at a trading post located here.

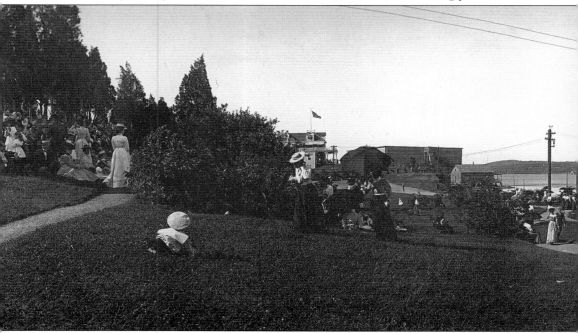

KINGSTON POINT PARK C. 1900. This site played an important role during the Revolutionary War. On October 16, 1777, about 1,200 British troops landed here and marched up to the village

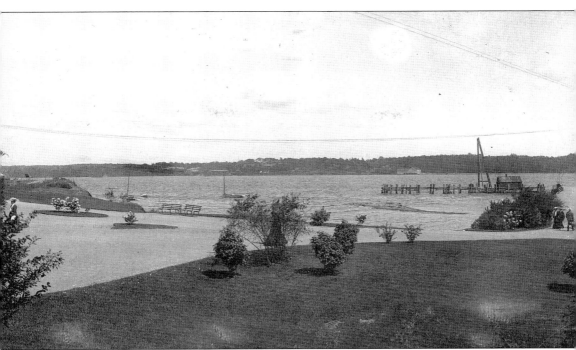

A ferry service was established here at the foot of Delaware Avenue to cross the Hudson River to Rhinebeck as early as 1680, and continued operations until the 1850s.

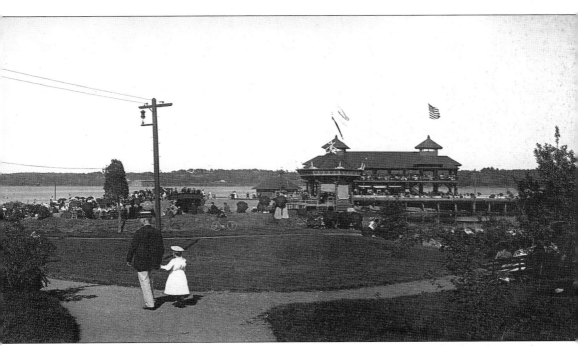

of Kingston, where they burned every home except one. Within three hours, the fires destroyed 100 homes, 100 barns, and hay barracks. The troops returned to their ships and sailed away.

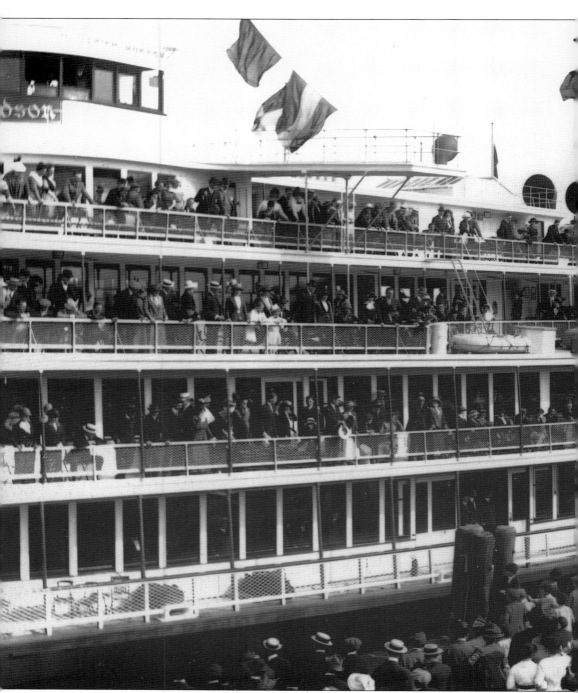

THE STEAMBOAT *HENDRICK HUDSON* AT KINGSTON POINT C. 1910. In 1906 a new steamer was given this name even though purists pointed out that Henry Hudson was an Englishman who sailed for the Dutch in 1609, and was never a "Hendrick." Huge crowds gathered at Newburgh—where the boat was built—as well as at Poughkeepsie, Kingston Point, and Albany to greet the new day-liner on her maiden voyage. (She continued in service until

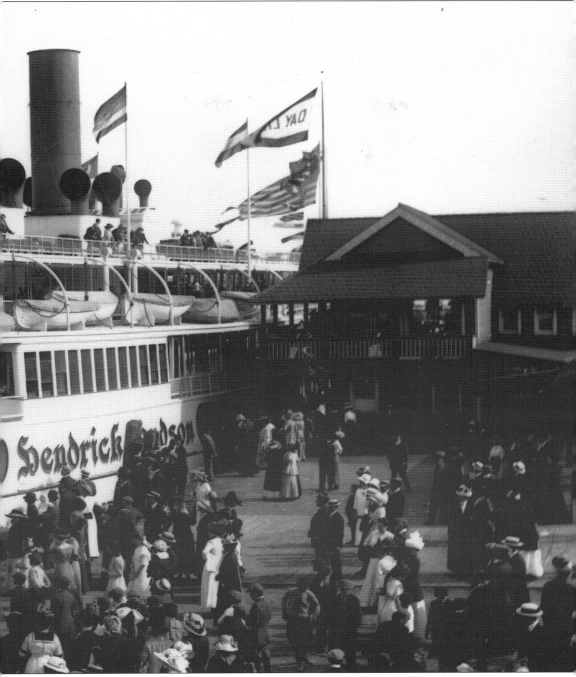

1948.) Hordes of people routinely flocked to welcome the day-liners that docked at Kingston Point. Every single person in this scene is dressed in his or her best clothes. For many passengers this was the start of their summer excursions to Catskill Mountain hotels; they would continue their travels by hopping aboard railroad connections in Rondout.

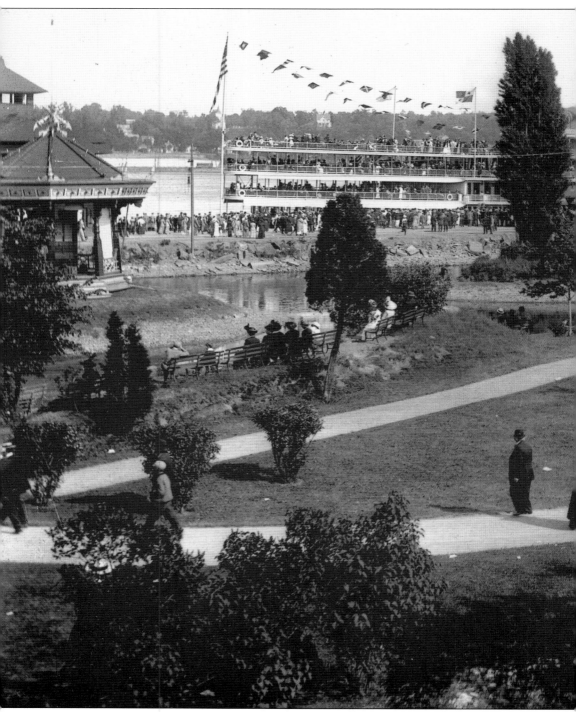

DAY-LINER AT KINGSTON POINT PARK C. 1910. In 1949 the Hudson River Day Line Corporation placed six riverfront properties for sale, including Kingston Point Park. The city of Kingston acquired the acreage, and in 1987 the Kingston Rotary Club began a project of

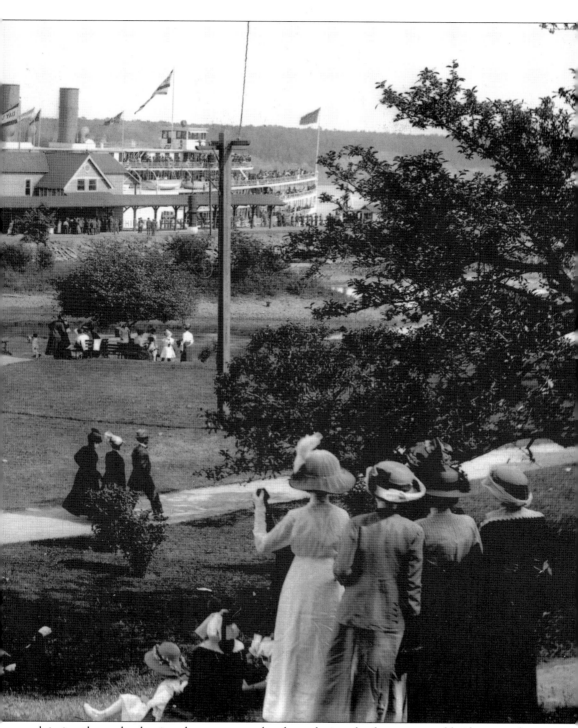

reclaiming the park: clearing the overgrown brush, replacing the front gate and bridge over the lagoon, and building a replica trolley station. Thank you to the Rotary Club.

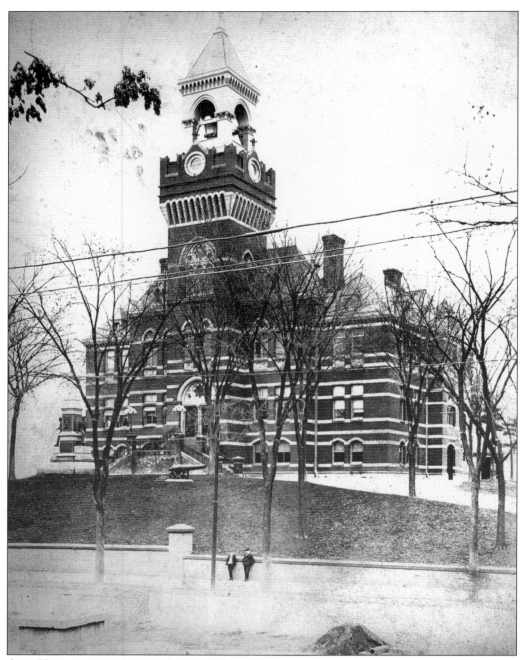

CITY HALL C. 1900, 420 BROADWAY. When Kingston and Rondout villages merged to become the city of Kingston in 1872, both fought to have the seat of government built in their sector. To satisfy both parties, state officials decided the site for the city hall building would be a hill on central Broadway that was located near the borders of the two villages. Architect Arthur Crooks won the building design competition in which 11 architects competed. Construction costs came to $48,000. In 1927 a blaze burned the building's upper floor, roof, and bell tower, and hundreds watched as the two-ton fire bell came crashing down and smashed on the front steps.

Three
PUBLIC BUILDINGS

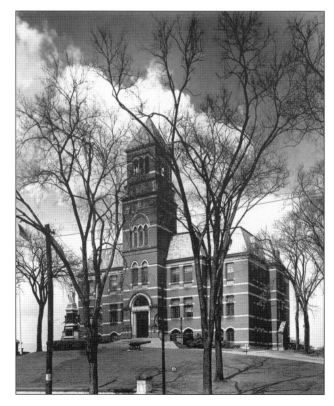

CITY HALL C. 1930, 420 BROADWAY. Old City Hall was vacated by city government in 1972 for a new site in the Rondout area. The late mayor T. R. Gallo spearheaded the restoration of the old building, and in May 2000 the city government moved back to the original city hall. The meticulous restoration included the plaster lunettes in the common council chamber that depicted the city's 350-year history, and the aldermen's desks that were reproduced to match the original furniture of 1872.

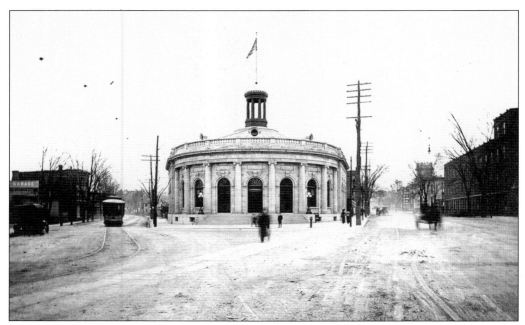

POST OFFICE C. 1908, 500 BROADWAY. No public building in Kingston was more venerated or mourned after it was razed in 1970 than the old post office. Built in 1907 of Indiana limestone and New Hampshire granite, its demolition inspired a rallying cry for local preservationists: "Remember the post office!" This photograph shows the trolley on Prince Street before brick paving was laid on the street in 1909.

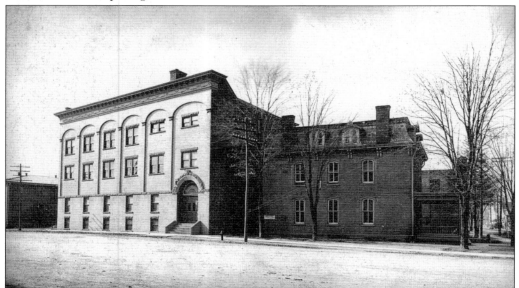

YMCA C. 1914, 507 BROADWAY. The new YMCA building in front was dedicated in 1913. Judge Alton B. Parker, United States presidential candidate in 1904, laid the cornerstone in 1912. The new structure was built next to the Grand Central Hotel (shown here at right of YMCA building), which housed the YMCA's administrative offices. The gymnasium to the rear was built in 1899.

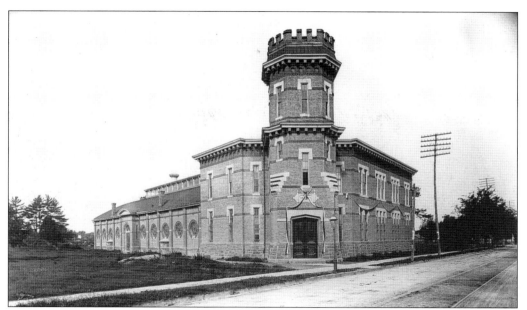

NEW YORK STATE ARMORY C. 1879, 467 BROADWAY. Horsecars were still running on Broadway when state funds were appropriated to build a centrally located armory. Hoffman Street was constructed on the left of the armory several years later.

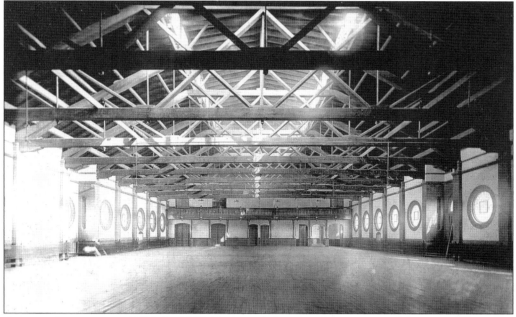

ARMORY INTERIOR C. 1900. In 1933, the armory became the property of the city of Kingston. Renamed the Municipal Auditorium, it hosted a variety of events: basketball games, boxing matches, pageants, auto shows, expositions, concerts, and balls. A highlight was the 1952 visit by Queen Juliana of the Netherlands and Eleanor Roosevelt for Kingston's 300th anniversary celebration. Today the building is home to the Kingston Recreation Department and is called the Midtown Neighborhood Center.

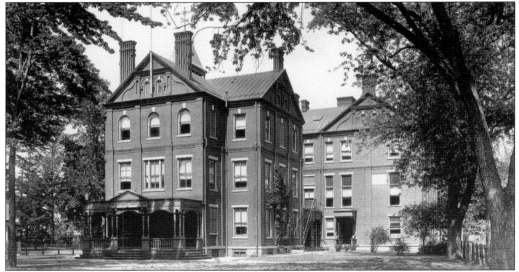

KINGSTON ACADEMY C. 1900, ACADEMY GREEN. Built in 1830 and remodeled over the years, it replaced the original site of Kingston Academy, founded in 1774 on the southwest corner of John and Crown Streets. The private high school became a public part of the Kingston Board of Education in 1864. Kingston Academy closed in 1915 when the new Kingston High School opened at 403 Broadway. The academy still has an active board of trustees who oversee the property.

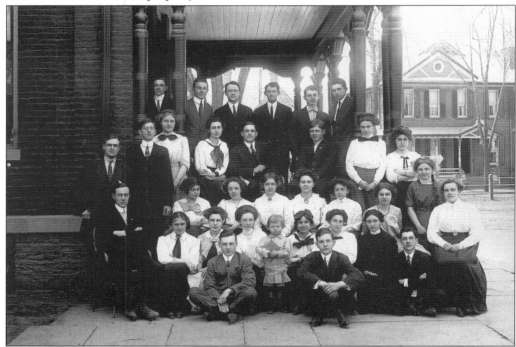

GRADUATING CLASS C. 1911 KINGSTON ACADEMY, ACADEMY GREEN. Not many of the graduates wear smiles for this solemn occasion, but their spirit of fun is evident in the small girl (front and center) tightly clasping a book. The building was demolished in 1916.

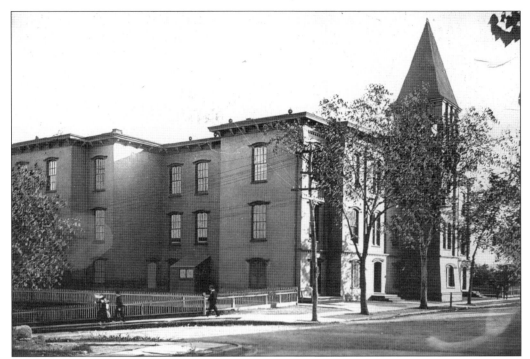

ULSTER ACADEMY C. 1900, 214 WEST CHESTNUT STREET. Built in 1870, this school provided excellent high school academics for the rapidly growing Rondout population. Later, as part of the Kingston school system, it became School No. 2 for the elementary grades. In the 1960s, the structure housed the newly founded Ulster County Community College.

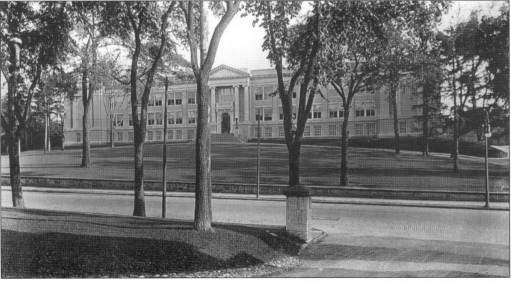

KINGSTON HIGH SCHOOL C. 1915, 403 BROADWAY. When the new high school opened in 1915, combining Kingston Academy and Ulster Academy, there was apprehension because of the intense rivalry between the two schools. Within a short time, however, harmony prevailed and rivalries were turned toward other high schools in the valley.

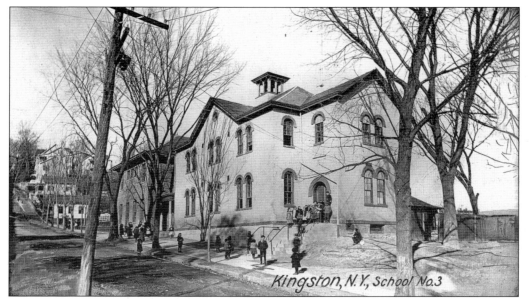

KINGSTON SCHOOL NO. 3 C. 1896, 114 CHAMBERS STREET. In 1868 a small brick school building was erected to meet the growing educational needs of Rondout. Enlarged in 1896 as pictured here, School No. 3 offered a school savings bank as well as a night school for those who were employed during the day. The building was razed in 1965 by the Kingston Urban Renewal Agency.

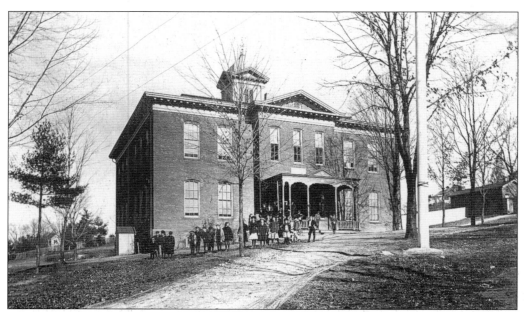

KINGSTON SCHOOL NO. 5 C. 1900, 21 WYNKOOP PLACE. The school was built in 1890 on Chapel Lane, later named Wynkoop Place. Several additions have been made over the years, and a determined group of parents and former students have staved off attempts at demolition to preserve their neighborhood school. Col. Frank L. Meagher served as principal for many years, and in 1951 the school was renamed for him.

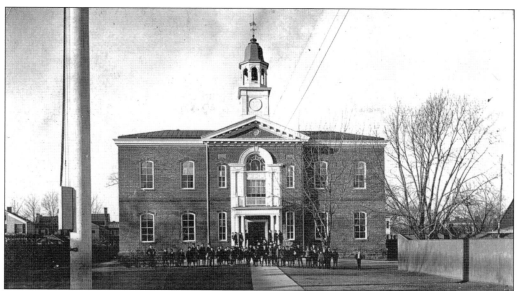

KINGSTON SCHOOL NO. 7 C. 1900, 61 CROWN STREET. This elementary school began as School No. 11 and later became No. 7. A disastrous fire in February 1901 completely destroyed the interior, leaving only the brick walls standing. The school was rebuilt, and in the 1920s the boys' entrance was located on Crown Street and the girls' on Green Street. In the 1970s the structure was converted to become the administrative offices of the Kingston City Schools Consolidated and was named for Vincent Cioni, who was business manager at the time.

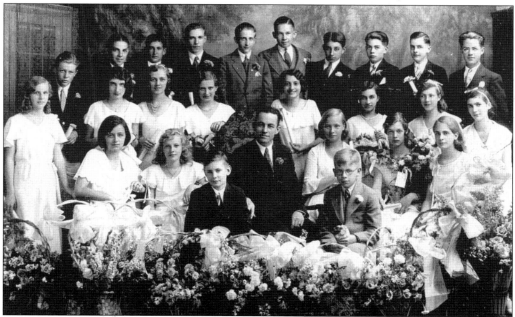

GRADUATION, KINGSTON SCHOOL NO. 7, 1931, 61 CROWN STREET. Some of the eighth-grade graduates pictured here are Frank Ostrander, Edwin M. Ford, Harriet St. John, Alice Darrow, Helen Nekos, Marie Larios, Edward Heaney, and Florence Snyder. Principal John J. Finnerty is seated in the middle.

CITY LAB C. 1938, 406 BROADWAY. This brick Colonial Revival structure was designed to harmonize with Kingston Hospital and city hall. Over the years it served as facilities for the city laboratory, the Ulster County Tumor Clinic, the American Cancer Society, the Ulster County Cerebral Palsy Treatment Center, and the County Mental Health Department. Erected in 1938, the building was demolished in 2002 as part of the hospital's expansion plans.

BENEDICTINE SANITARIUM C. 1912, 105 MARY'S AVENUE. On November 1, 1901, the Sisters of St. Benedict opened temporary quarters on West Chestnut Street, and on February 22, 1904, the new Our Lady of Victory Sanitarium was dedicated on Mary's Avenue. The land was purchased from C. B. O'Reilly, Inc.

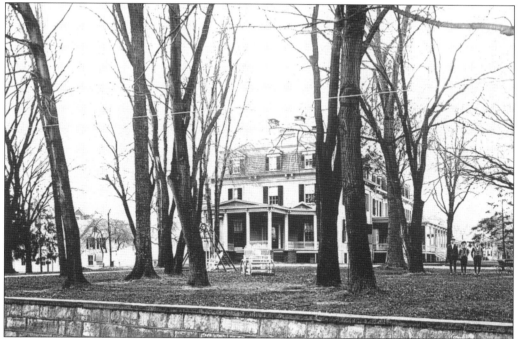

SAHLER'S SANITARIUM C. 1910, 61 WALL STREET. This handsome residence was earlier the home of Marius Schoonmaker, author of the *History of Kingston*, published in 1888. It was here that Dr. Charles O. Sahler, born in Ulster Park, opened his Sanitarium for the Treatment of Diseases by Suggestion *c.* 1899. Sahler's staff and patients numbered up to 275, and he maintained a large farm in the area that produced all the food for the facility.

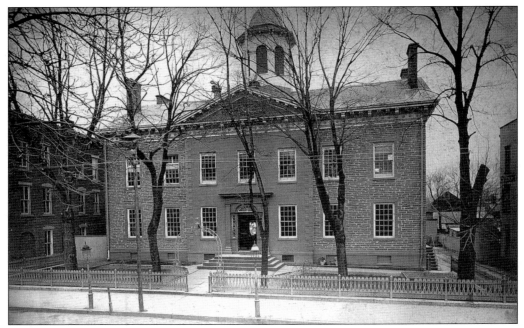

COURTHOUSE C. 1910, 285 WALL STREET. Built in 1818, the Ulster County Courthouse stands on the same site of the 18th-century courthouse in which the New York State constitution was written in 1777, and which was burned by the British that same year. Sojourner Truth, who became a nationally known abolitionist, sued for and won her son's freedom from slavery in Alabama in the present courthouse. In recent years, the building has been undergoing complete restoration by the county.

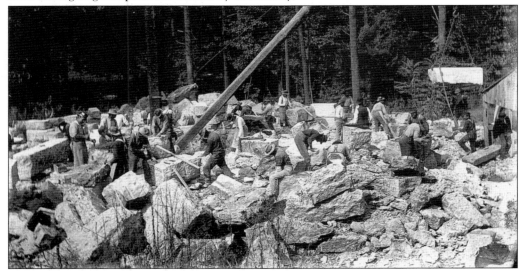

QUARRYING STONE FOR ULSTER COUNTY JAIL C. 1899, 285 WALL STREET. Workers select blocks of Ulster County limestone for the jail construction project, which is under the supervision of Albert K. Coutant's Ulster Planing Mill, located at East Strand and North Street. The firm carried out the planing, matching, sawing, and trimming of the stone that was used to build the new jail behind the courthouse.

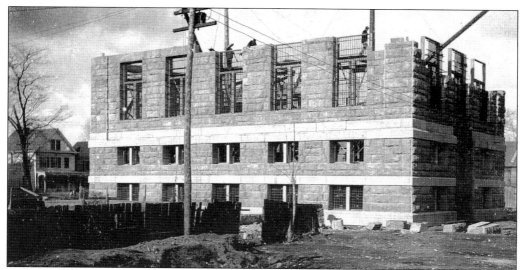

JAIL DURING CONSTRUCTION C. 1899, 285 WALL STREET. Myron S. Teller was the architect, and Campbell and Dempsey, Kingston masons and builders, were the contractors for the new county jail. In a *Kingston Weekly Freeman* article on July 11, 1901, an inspection committee of the New York State Prison Commission stated that this was the most perfectly constructed jail in the state and was a model in every particular.

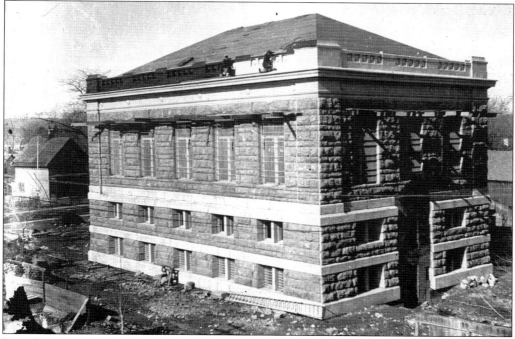

JAIL CONSTRUCTION NEW ROOF C. 1899, 285 WALL STREET. The same *Freeman* article states: "The building measures 50 x 80 feet, is four stories high and is completely fireproof. There are four floors, sixteen cells on each floor, each is 6 feet by 7 feet 6 inches and 8 feet high. Large windows on all sides admit an abundance of light. The entire cost of the new jail and the refitting of the old jail is about $80,000."

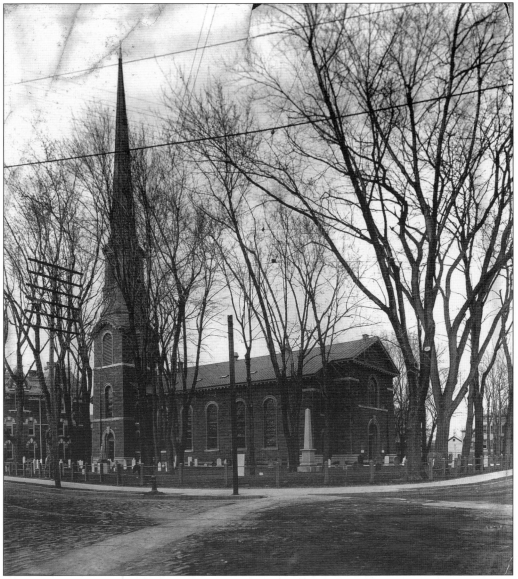

OLD DUTCH CHURCH C. 1880, 272 WALL STREET. Organized in 1659, the Dutch Church was the mother church to 40 Dutch Reformed congregations in this area. Sermons were delivered in Dutch until 1808, when the younger members demanded that English be spoken. The first elected governor of New York State, Gen. George Clinton, and more than 70 Revolutionary War soldiers are buried in the graveyard.

Four

CHURCHES

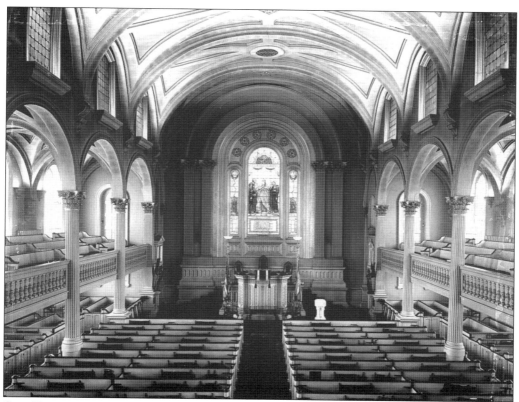

OLD DUTCH CHURCH INTERIOR C. 1891. The present church was built in 1852 of native bluestone and was designed by noted architect Minard LaFever. David Houghtaling gave the Tiffany window in memory of his parents. Listed on two marble tablets on the front wall are the names of more than 80 persons who are buried beneath the sanctuary.

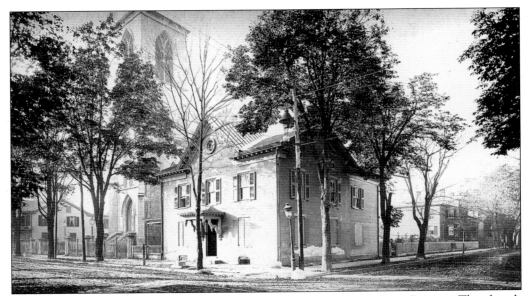

FAIR STREET REFORMED CHURCH AND PARSONAGE C. 1880, 209 FAIR STREET. The church was built in 1850 of native limestone that was quarried on upper Pearl Street. Members of the First Dutch Reformed Church willingly transferred their membership here to form the new congregation. The building on the right served as the parsonage for 35 years until its demolition c. 1890. It was originally a pre-Revolutionary limestone house that belonged to Abraham Freer, and later was altered.

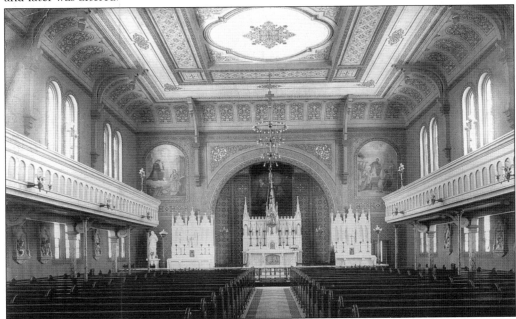

ST. JOSEPH'S CHURCH INTERIOR C. 1880, 60 WALL STREET. This was the Dutch Reformed Church from 1836 until 1852, when the congregation moved to its current home across the street. The building served as an armory during the Civil War. In 1869 St. Joseph's Roman Catholic Parish acquired the property, and over the years the building has been extensively altered.

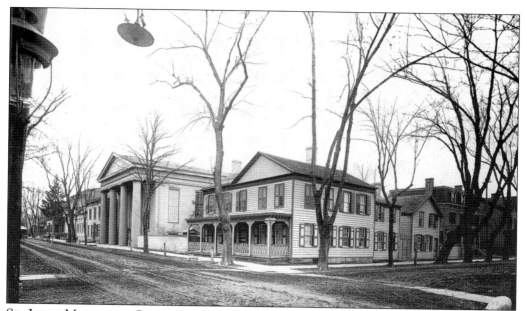

St. James Methodist Church c. 1892, 240 Fair Street. The church and parsonage, built in 1844, stood on the corner of Pearl and Fair Streets. The Greek Revival–style church, with four Ionic columns, had separate sides for men and women. Edward O'Neil, an early Methodist, established a Sunday school here for the children of slaves.

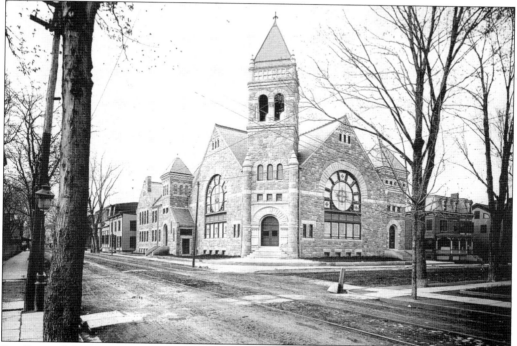

St. James Methodist Church c. 1894, Corner of Fair and Pearl Streets. On the same site, the new church was built in the Romanesque style of serpentine green stone and was furnished for a total cost of under $75,000. Its beautiful Tiffany windows cost $1,300.

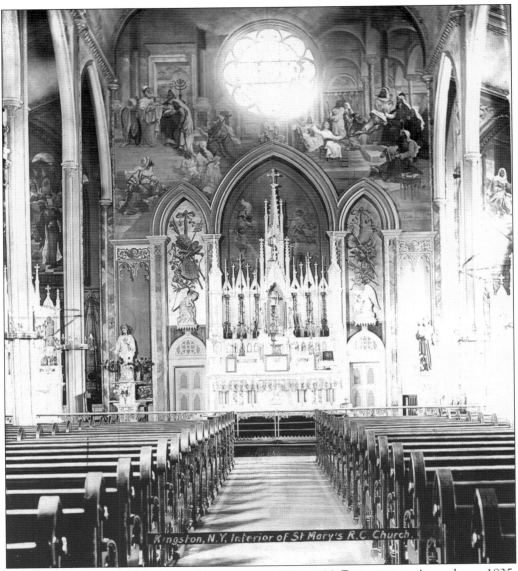

Kingston, N.Y. Interior of St Mary's R.C. Church.

ST. MARY'S ROMAN CATHOLIC CHURCH C. 1900, 166 BROADWAY. As early as 1835, collections were taken up to establish a parish in Rondout. By 1842 a parcel of land had been purchased and a small frame structure was erected. In 1895 the present church was completed. It is adorned with magnificent murals painted by noted artist Filippo Costaggini, a personal friend of the Right Reverend Monsignor Richard L. Burtsell, the church's pastor at the time.

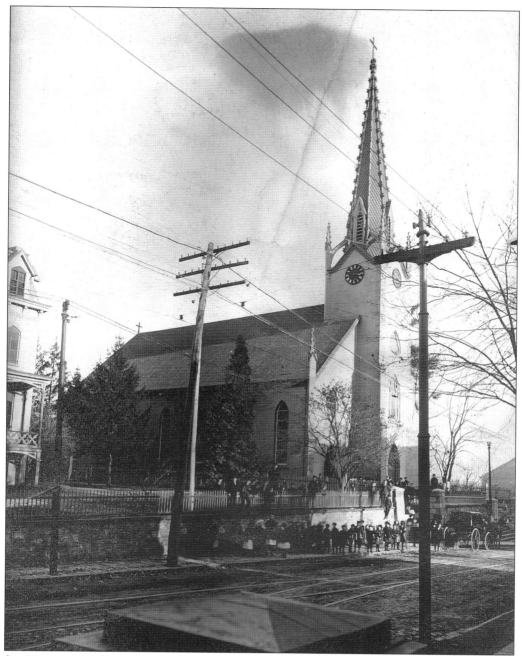

St. Mary's c. 1900, 166 Broadway. Could these schoolchildren have been photographed just before they crossed Broadway to attend their brand-new grade school? This edifice is a far cry from the humble beginnings of the parish 50 years prior, when Ann O'Reilly, a former Quaker, worked tirelessly to raise funds for the first building. The street behind the church, Ann Street, was presumably named for Ms. O'Reilly.

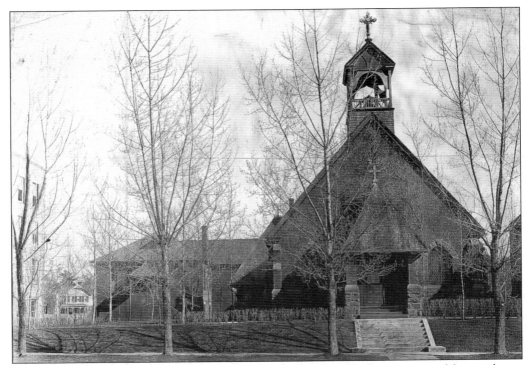

CHURCH OF THE HOLY CROSS C. 1892, 30 PINE GROVE AVENUE. There was a need for a midtown church to minister to the working people who lived near the many factories in the area. The Fuller Shirt Factory and the American Cigar Company were both on Pine Grove Avenue. The church of local brick and bluestone was enhanced in the 1920s with interior hand-carved woodwork imported from Italy. Many concerts are held here because of the building's excellent acoustics.

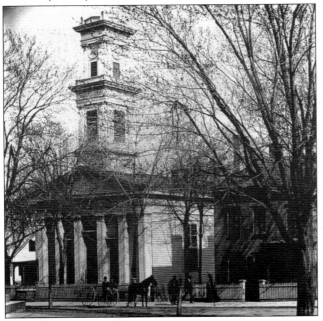

RONDOUT PRESBYTERIAN CHURCH C. 1870, 50 ABEEL STREET. Due to the opening of the Delaware and Hudson Canal Company in 1828 and the rapid increase in the population of Rondout, the need for a Protestant church arose. This framed building remained for 40 years until 1873, when a brick church of larger capacity was erected across the street.

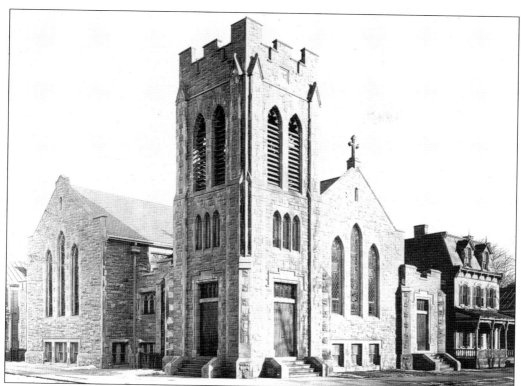

THE EVANGELICAL LUTHERAN CHURCH OF THE REDEEMER C. 1922, 104 WURTS STREET. In 1897 some congregants of the Trinity Lutheran church, where services were conducted in German, decided to form an English-speaking church. Fifteen years of fund-raising took place before the congregants were able to purchase the property at the corner of Wurts and Rogers Streets. The Gothic Revival building of marble and limestone was dedicated in 1913.

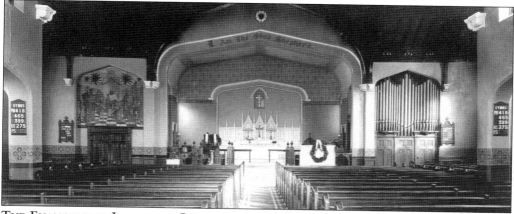

THE EVANGELICAL LUTHERAN CHURCH OF THE REDEEMER 1922, INTERIOR VIEW. One of the notable features of the church is the tower chime that rings for Sunday services and concerts. The eleven bells, weighing 13,000 pounds, were cast in 1913 by the Meneely Foundry of Watervliet, New York. Each bell is inscribed with a passage from scripture, following the ancient custom of blessing bells for use in liturgical worship. In 1984 a recital was held with more than 3,000 people in attendance.

JACOB TEN BROECK HOUSE C. 1930, 169 ALBANY AVENUE. The house was built in 1803 by Jacob Ten Broeck, who lived here until his death in 1829. The next owner, Peter G. Sharp, also owned the land across the street that became the Sharp Burying Ground. Peter Masten, who had a shoe and boot business on South Wall Street, also occupied the house for many years. Subsequently, Mrs. John Forsyth took up residence, and later, John D. Schoonmaker Jr., owner of Island Dock, lived here.

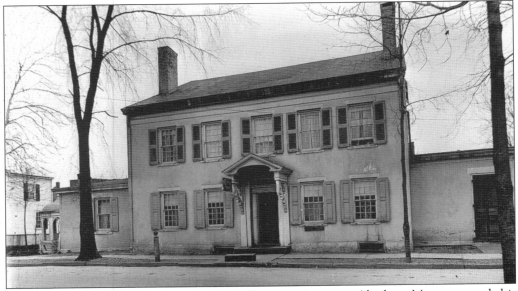

ABRAHAM MASTEN HOUSE C. 1920, 317 CLINTON AVENUE. Abraham Masten owned this house in 1758. After it was burned by the British on October 16, 1777, the house was rebuilt by his son Abraham Jr., who lived here until 1836. Abraham Jr.'s daughter Anna married Francis C. Voorhees and the couple resided here with their nine children until 1885. Across the street, Voorhees Lane led down to the lowlands, now Kingston Plaza. The Masten House was demolished in the 1960s and the site today is a parking area for Senate House visitors.

Five
PRIVATE RESIDENCES

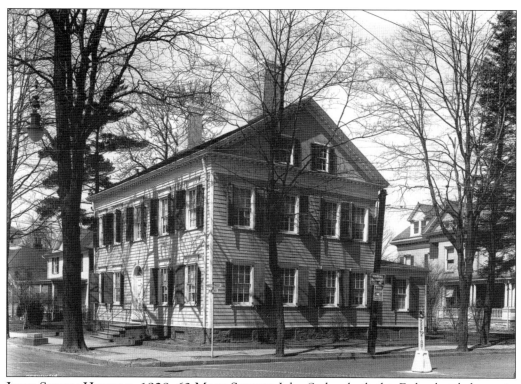

JOHN SUDAM HOUSE C. 1928, 63 MAIN STREET. John Sudam built this Federal-style house in 1812 for his new bride, Mary Harrison Elmendorf. His law office was on the north side. In 1820 Sudam was elected to the New York state senate and to further his political ideas he founded the newspaper *The Craftsman*. The house was bought in 1938 by antiques dealer Fred J. Johnston, who used it as both his home and a showroom. At his death in 1993, he bequeathed the house and its contents to the Friends of Historic Kingston to be maintained as a museum.

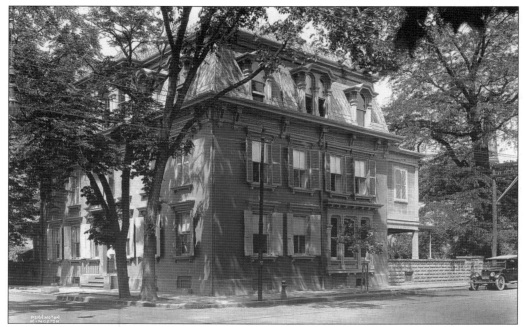

JOHN FORSYTH HOUSE C. 1923, 41 PEARL STREET. This building was originally a stone house built by Severyn Bruyn, the son of Col. Jacobus Bruyn of North Front Street. Severyn was cashier at the Middle District Bank and had a business office at the rear of the building. His son Augustus Bruyn lived here with his sister Mary Catharine Forsyth and her children. The Forsyths owned large tracts of land and donated the land that became Forsyth Park.

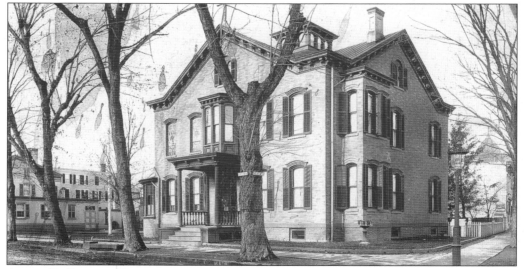

ALTON B. PARKER HOUSE C. 1900, 1 PEARL STREET. Around 1872 Cornelius Burhans built this brick residence next to his coal and lumberyard, where the Kirkland Hotel now stands. Judge Alton B. Parker, Democratic presidential candidate in 1904, bought the house and lived here until he moved to Rosemount in Esopus. A. Carr and Son acquired the property in 1915 and remained the owners until Ulster County purchased it. Although the house faced the threat of demolition during the 1980s, it was successfully renovated to become county offices.

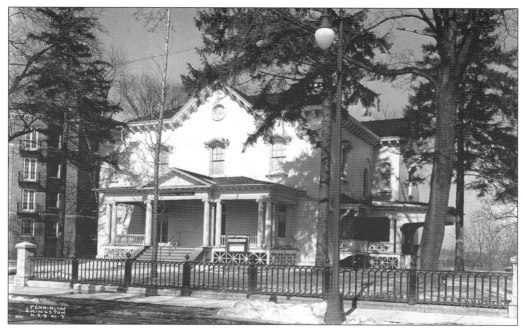

JAMES C. FORSYTH HOUSE c. 1941, 31 ALBANY AVENUE. Judge James Forsyth and his wife, Mary Catharine Bruyn, built this mansion in 1851. Two years later, due to his dishonest dealings, Judge Forsyth fled the country, and his wife and five children moved in with her brother at 41 Pearl Street. John C. Brodhead, Ulster County treasurer and president of the Rondout and Oswego Railroad, later lived here, followed by Samuel Gray, merchant and corporate president of the Stuyvesant Hotel, who owned the house until 1931.

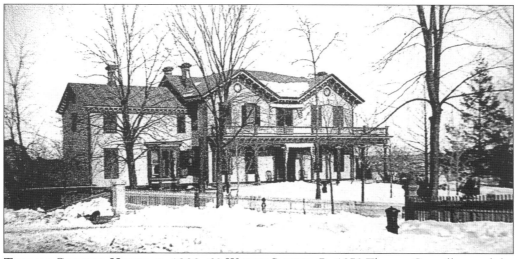

THOMAS CORNELL HOUSE, c. 1900, 60 WURTS STREET. By 1870 Thomas Cornell owned the entire block bounded by Wurts, Spring, Post, and Hunter Streets in Rondout, and that is where he built this large Victorian residence. By that time, the Cornell Steamboat Company was the largest individual steamboat owner in the United States, with a fleet of 19 steamboats valued at $2 million to $3 million. The house was demolished in the early 20th century, and a grassy park occupies the property today.

LUKE NOONE HOUSE C. 1900, 172 PEARL STREET. This fine Victorian residence was built of brick with limestone trim, that possibly was quarried on the same site. Noone's Lane, which runs from Linderman Avenue to Pearl Street, had a road surface of rough quarried stone that resulted in a bumpy ride for cars and bicycles 70 years ago. The six-foot-high, rough-cut limestone wall that ringed Noone's property still exists.

JOHN H. CORDTS HOUSE C. 1900, 132 LINDSLEY AVENUE. Born in the province of Hanover, Germany, John H. Cordts came to America at age 14. He began in the brick business in Cornwall, New York, and moved up the river to Rondout in 1852. In 1865, he founded the firm of Cordts and Hutton Brick Manufactory at Kingston Point. Noted for his civic contributions, he served on the common council for nearly 18 years.

DR. DAVID KENNEDY HOUSE C. 1900, 10 EAST CHESTNUT STREET. Edgar B. Newkirk built this mansion *c.* 1865 and had likenesses of his children carved in the newel post. He was a real-estate promoter, for whom Newkirk Avenue was named. The house was later bought by Dr. David Kennedy, physician and promoter of an elixir, Kennedy's Favorite Remedy. He was mayor of Kingston from 1892 to 1895. In 1933, the house was sold to Jay and Lucia Klock, editor and publisher of the *Daily Freeman*.

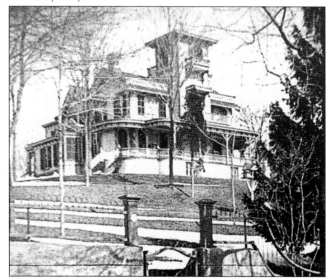

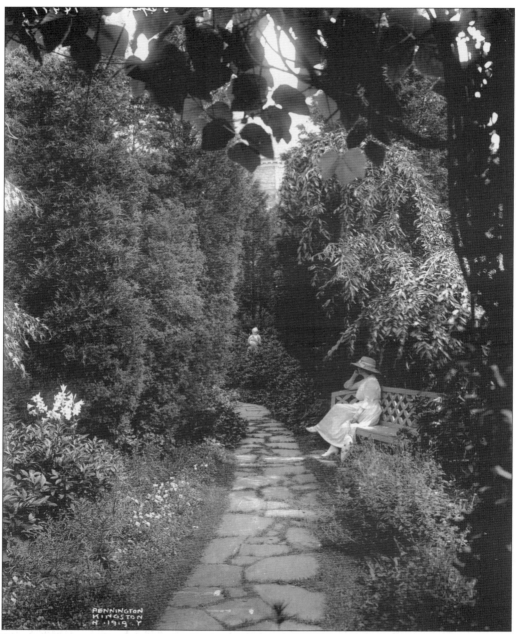

ISABEL HUTTON COYKENDALL'S GARDEN C. 1919, 166 WEST CHESTNUT STREET. Isabel Hutton Coykendall, pictured here, probably had the most beautiful and extensive private gardens in Kingston. The daughter of William H. and Jane K. Hutton, and wife of Edward Coykendall, Isabel was a true lover of nature and was one of the founding members of the Ulster Garden Club. She died May 22, 1928, and is buried at Montrepose Cemetery.

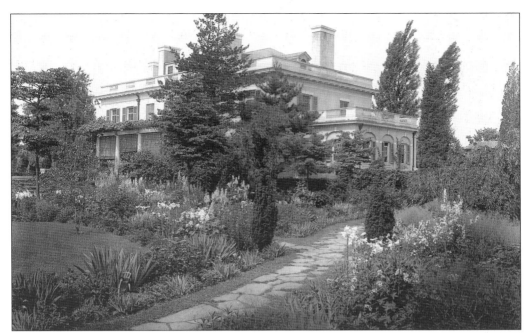

EDWARD COYKENDALL HOUSE C. 1919. Edward Coykendall began work as general superintendent of the Ulster and Delaware Railroad, where his father, Samuel, was president. Edward insisted on purchasing the latest locomotives and modern coaches for the railroad, which ran from Weehawken, New Jersey, to the Catskills. When Samuel died in 1913, Edward became company president for the next 20 years. He also was president of the First National Bank of Rondout for 15 years.

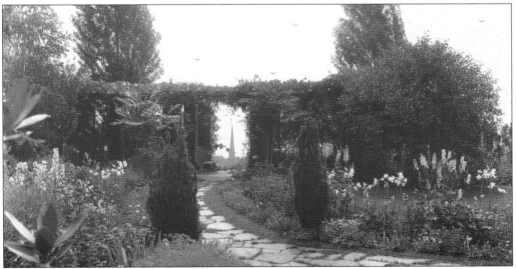

EDWARD COYKENDALL GARDEN C. 1919. With the Trinity Evangelical Lutheran Church visible through the trellis and the family dog on guard, this view shows how pleasing Isabel Coykendall's gardens were. Upon her death in 1928, Judge Alphonse T. Clearwater, in a memorial tribute, spoke of Isabel as being "endowed with an indefinable charm and grace that endeared her to all."

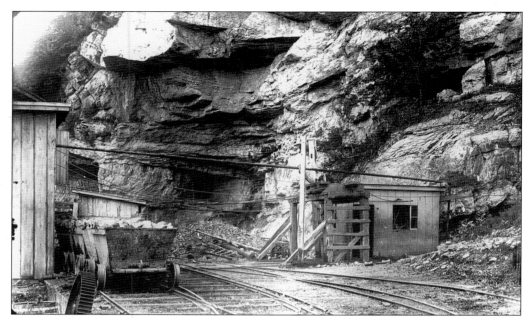

CEMENT MINE, NEWARK LIME AND CEMENT COMPANY C. 1870, 155 EAST STRAND. Based in Newark, New Jersey, the company established additional quarries in Ponckhockie. Owner Calvin Tomkins sent his son-in-law James G. Lindsley here in 1846 to build kilns and mills to produce cement. Operations continued for 50 years. Lindsley was elected as the first mayor of the newly formed city of Kingston in 1872.

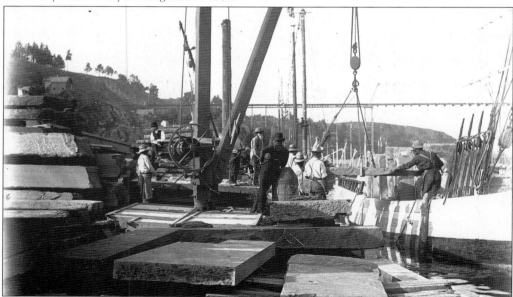

LOADING BLUESTONE C. 1885, RONDOUT. Abeel Street from Wilbur to Eddyville was lined with docks owned by the large dealers of bluestone. Here the finished stones were loaded on sloops for transport to market. Quarried throughout Ulster County, the bluestone was sawed, rubbed, planed, and axed to make sidewalks, curbstones, gutters, sills, lintels, hearths, mantels, steps, and foundations.

72

Six

COMMERCE

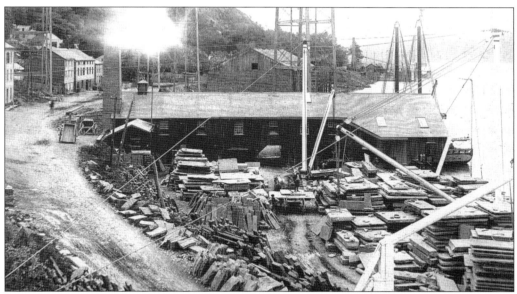

BLUESTONE YARD C. 1885, 370 ABEEL STREET. The bluestone yard of Donovan and Sweeney was established in 1860 under the railroad bridge on Abeel Street. After Donovan withdrew in 1870 and business partner James Sweeney died in 1874, Sweeney's wife, Elizabeth, continued to run the business, joined by her son, James J. Sweeney. The firm owned extensive quarries in Ulster County and employed hundreds of men. Some of the stones weighed as much as 25 tons. One stone that was destined for use in the Vanderbilt mansion in New York City measured 17 feet by 10 feet and 10 inches thick.

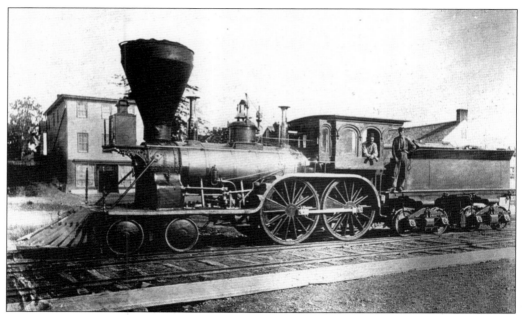

First Engine of the Wallkill Valley Railroad, c. 1880. In 1866 a group of entrepreneurs formed the Wallkill Valley railroad company to transport milk and farm produce from Kingston to Goshen. This photograph shows the first steam engine to traverse the line. The company later became part of the New York Central System.

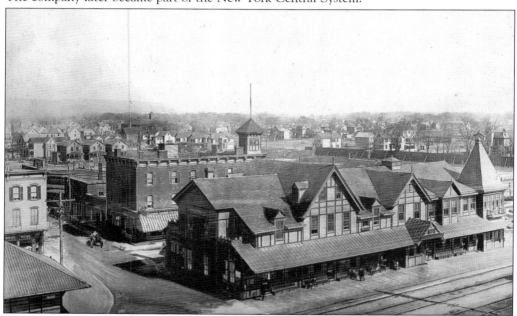

West Shore Railroad Depot c. 1910, Railroad Avenue. The depot was built in 1883 to accommodate passengers from the West Shore Railroad, which opened in 1885. The Ulster and Delaware and the Wallkill Valley lines crossed the West Shore tracks at this intersection. The depot's second floor contained offices and living quarters for the manager and staff. Mary Carle, a very popular waitress in the first-floor restaurant, worked and lived there for over 30 years.

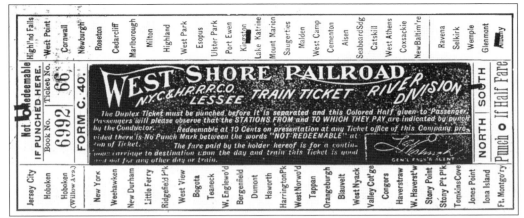

WEST SHORE RAILROAD TICKET. This ticket is punched for a trip south from Albany to Kingston and shows how many stops there were between the two cities. The West Shore company failed financially and was acquired by the New York Central in the early 20th century.

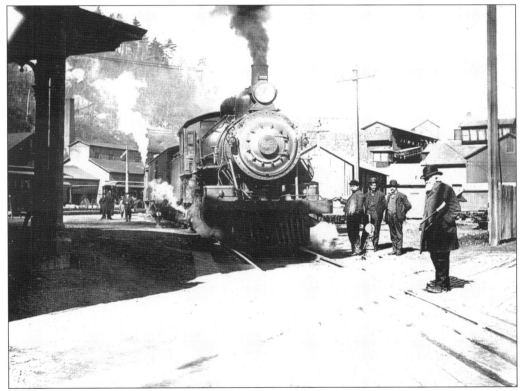

TRAIN AT ULSTER AND DELAWARE RONDOUT STATION c. 1890. This photograph shows Engine 29 about to leave the station. Since the train crossed the street at grade level, a flagman had to stop vehicle and pedestrian traffic. This practice continued as late as the 1950s, when it was noted that the railway employed 21 crossing watchmen or flagmen in Kingston. The man in the derby hat is identified as Tim Collins.

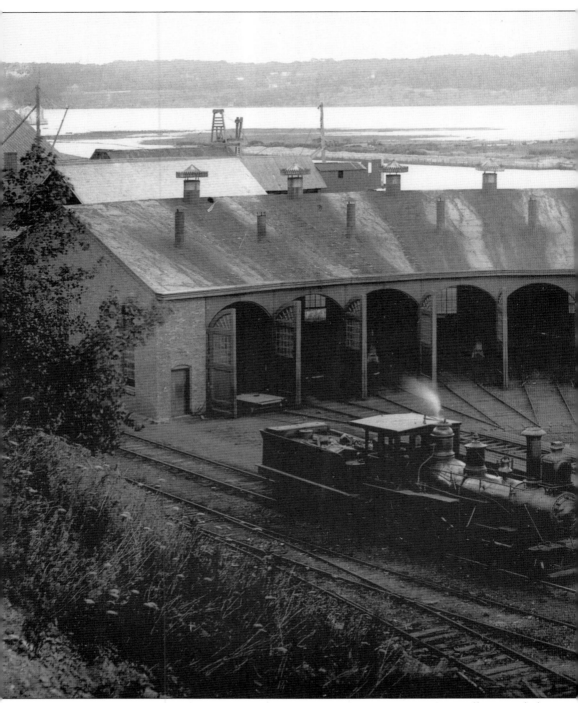

ULSTER AND DELAWARE RAILROAD YARD C. 1890, EAST STRAND. Originally named the Rondout and Oswego Railroad, Thomas Cornell changed the title to the Ulster and Delaware (U&D) when he became the owner in 1875. Running 108 miles from Kingston Point to Oneonta, the U&D helped to develop the Catskills as a summer resort. In 1905, U&D president

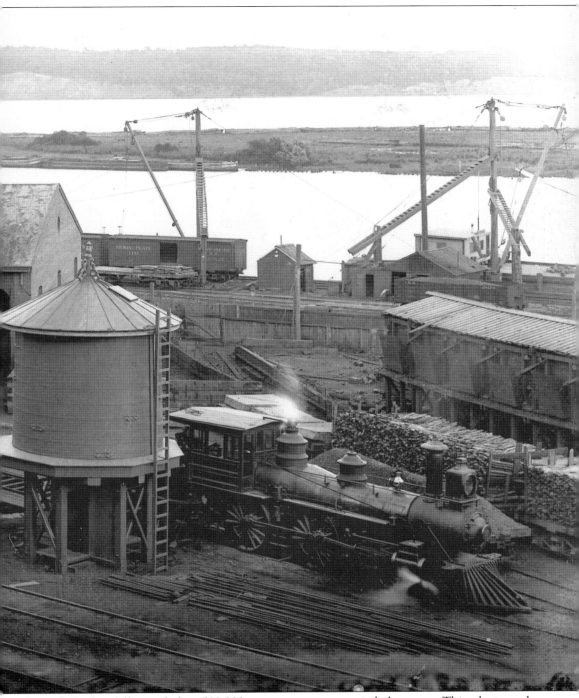

Samuel Coykendall noted that 500,000 passengers were carried that year. This photograph shows the six bays in the repair shop and the turntable at the left that diverted the locomotives to the bays. In the early 1930s New York Central acquired the U&D, and all the buildings—including the station, turntable, machine shop, storerooms, and tracks—were demolished.

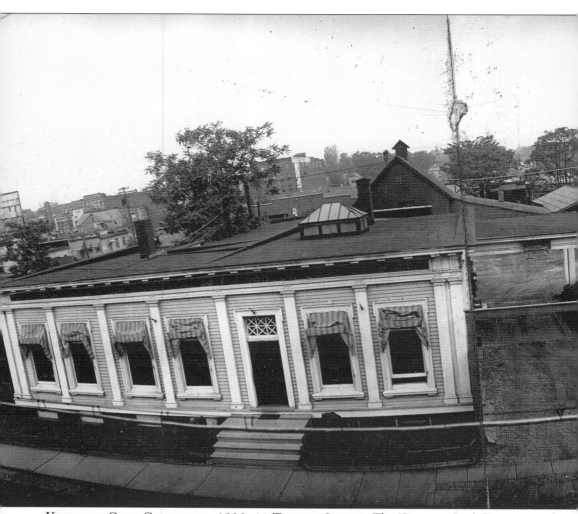

KINGSTON COAL COMPANY C. 1930, 11 THOMAS STREET. The Kingston Coal Company and the North River Coal Company were established in 1901 with Frank R. Powley as president. On July 20, 1907, disaster struck when a bolt of lightning hit the coal elevator, resulting in a

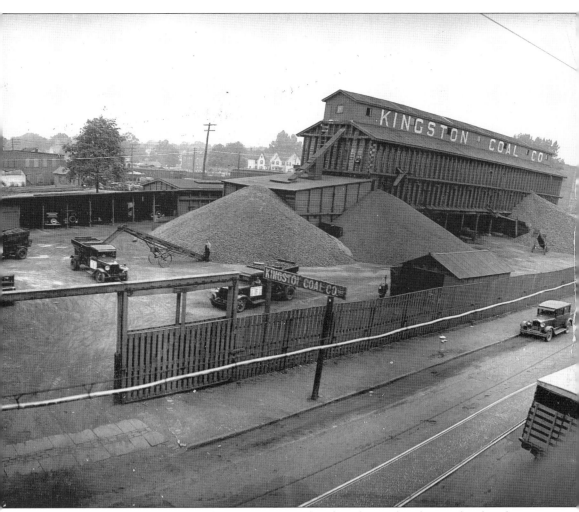

fire that destroyed the structure. About 3,000 tons of coal in the yard and several railroad cars were completely burned. Soon rebuilt, the corporation by 1930 owned several other yards under the direction of the Rodie Family and, later, Herbert L. Shultz Jr.

UNIVERSAL ROAD MACHINERY COMPANY C. 1910, 27 EMERICK STREET. Known originally as the Julian Scholl Company, by 1909 it was incorporated as the Universal Road Machinery Company. By 1918 it was locally owned and Alexander B. Shufeldt became president. The

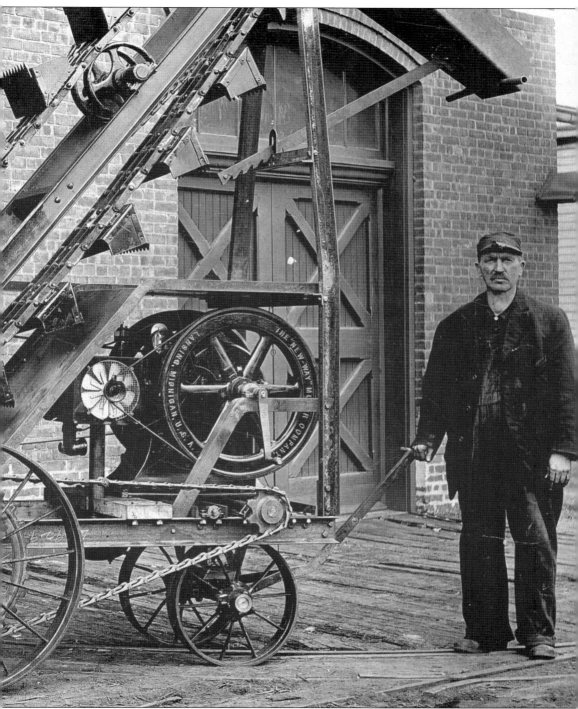

"Reliance" trademark became known not only in the United States but all over the world as well. The conveyor belt in the photograph is one example of the products the company manufactured for mining, quarrying, and road building.

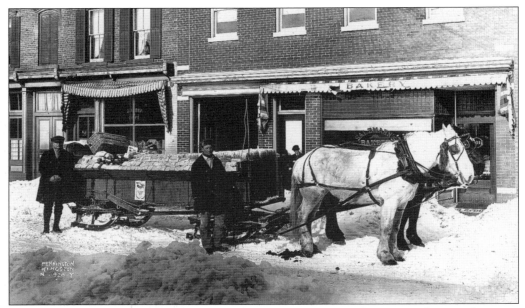

SALZMANN'S BAKERY C. 1920, 99–101 ABEEL STREET. Louis Salzmann was born in Germany and came to America in 1853, settling in Rondout. By 1865 he had an established bakery on Abeel Street that featured "Mother's Bread." In competition, his brother John W. began a bakery in Ponckhockie that offered "New England Bread." The photograph shows employees Milton Walker and Art Dietz on Abeel Street with a sleighload of bread ready for delivery on a winter's day. The Salzmann family was in business for over 100 years.

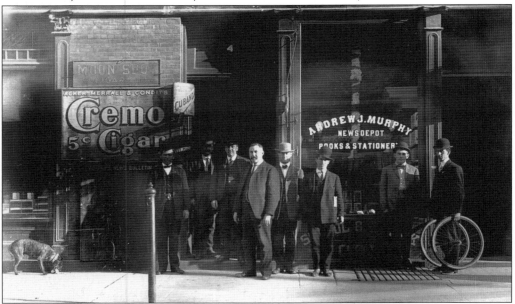

MURPHY NEWS DEPOT C. 1900, 41 EAST STRAND. Andrew J. Murphy Sr. stands in front of his establishment with a well-dressed group of businessmen. Founded in 1900, the business sold newspapers, books, and stationery and also had a contract to provide Ulster and surrounding counties with school textbooks. In 1936, the business moved to 12 East Strand.

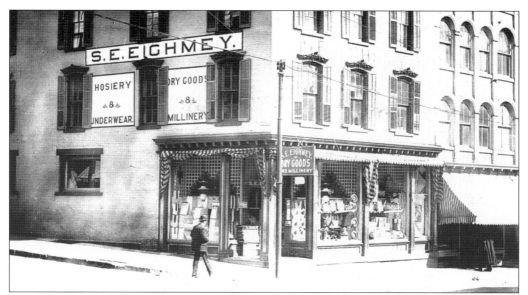

EIGHMEY DRY GOODS C. 1900, 26 BROADWAY. Sherman E. Eighmey began his career as a clerk in 1896, and by 1902 he had opened his own dry goods business at this site on the corner of Mill Street. With the trolleys running by his front door, his business flourished. Eighmey died in 1924, and his building was torn down in 1928, replaced by the new Rondout Savings Bank building.

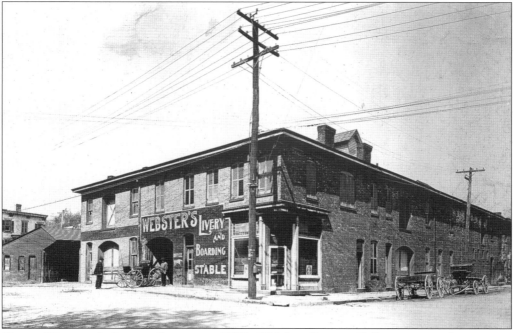

GROVE WEBSTER'S LIVERY STABLE C. 1900, 29 MILL STREET. Following an early career in banking and the retail hardware business, Grove Webster established a livery and boarding stable here in 1891. An active civic leader, he was appointed city treasurer in 1871 and served until 1888. Webster was the first treasurer for the newly formed city of Kingston. In 1903 he was elected sheriff of Ulster County for a term of three years.

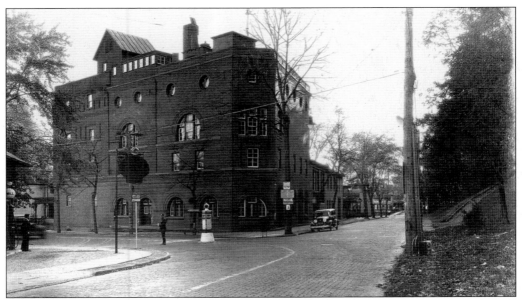

GEORGE HAUCK AND SONS BREWING COMPANY C. 1930, 64 MCENTEE STREET. George Hauck came to Kingston in 1863 and formed a partnership with George Dressel to produce beer. After he bought out Dressel in 1882, Hauck brought his sons Adam and John into the business in 1890. The main building on the corner of Wurts and McEntee was constructed in 1884, with a bottling plant at the corner of McEntee and Hone Streets. Prohibition closed down the operation, and the buildings were demolished in 1942.

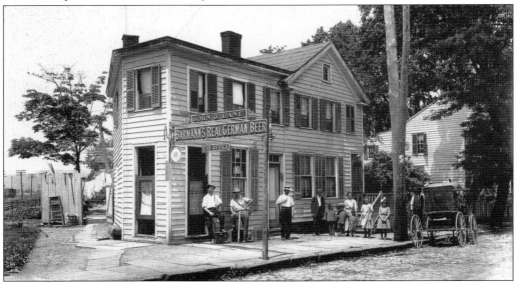

JOHN LANE SALOON C. 1913, 495 WASHINGTON AVENUE. John J. Lane, a bartender, opened his own business in 1899, and lived upstairs from the saloon with his wife and five children. The property adjoined the Ulster and Delaware Railroad and its uptown depot. When Prohibition came in 1920, Lane opened a grocery. The large tree seen near the horse and buggy served a dual purpose as a telephone pole. The area of Washington Avenue extending from North Front Street to the Esopus Creek was known as Higginsville.

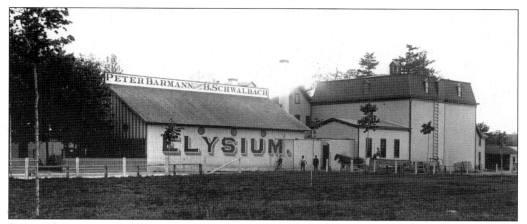

PETER BARMANN BREWERY C. 1900, 30 BARMANN AVENUE. Peter Barmann came to America in 1857 and soon was apprenticed to his uncle, Balthazar Schwalbach, in the brewing business. These buildings were constructed *c.* 1885 and the brewery produced lager beer, ale, and porter. The word painted on the outside of the building, *Elysium,* is a Greek word meaning paradise, and such it was until 1920, when Prohibition began. In an attempt to continue production, the brewery ran a rubber hose through a city sewer line to a side-street bottling plant, but it was eventually discovered.

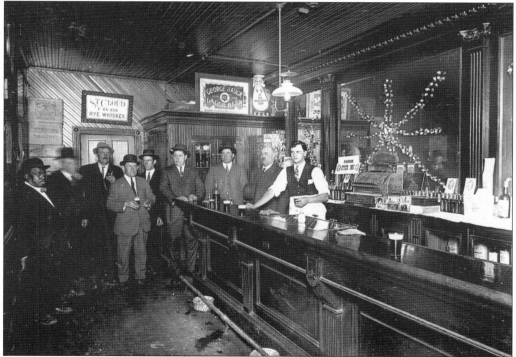

HOTEL ARCADE BAR C. 1914, 583 BROADWAY. In 1879 this building at the corner of Cedar Street was listed as the Union Avenue Hotel. In 1885 it became the Kingston City Hotel; in 1896, the Railroad Hotel; and in 1914, the Hotel Arcade. With proprietor Charles Formenton behind the bar, patrons waited for their beer while the photograph was being taken. Local brews were available, such as Hauck's special Red Monogram.

West Shore Hotel c. 1920, 37 Railroad Avenue. Located on the corner of Railroad Avenue and Thomas Street, across from the West Shore Railroad Station, the hotel was originally owned by Frederick Bauer and named Bauer's Hotel. In 1916, with the opening of the restaurant here, the name was changed to the West Shore Hotel and Restaurant.

Santa Claus Hotel c. 1900, 545 Abeel Street. Built shortly after the end of the Civil War, this hotel, owned by Casper Schick, was directly across the street from the William B. Fitch Bluestone Office. For 40 years the crews of the Fitch River steamboat, the *Santa Claus*, stayed here while in port. This photograph, with Casper standing seventh from the left, appears to be a gathering of the Schick family.

HOTEL EICHLER C. 1923, 41 RAILROAD AVENUE. Adolph Eichler came to Kingston *c.* 1918 and built this hotel and restaurant near the Ulster and Delaware Railroad depot. The hotel flourished when the West Shore Railroad depot was built. Eichler died in 1922, and John Tancredi became the hotel's proprietor in 1923. A sign in the window notes "Eichler Restaurant Now Open for Business." By 1960 the business had closed, and the building was destroyed by fire in the 1970s.

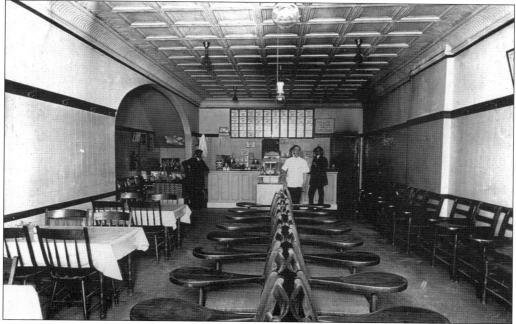

ROSE AND ACKERT RESTAURANT C. 1916, 25 RAILROAD AVENUE. William Rose partnered with Gilbert J. Ackert to run this restaurant. Just before World War I, items on the menu included oyster stew for 20¢, a ham omelet for 20¢, and a sliced ham sandwich for 10¢. Ackert eventually ran the business alone until he sold out in 1930. Note the armrest seating arrangements.

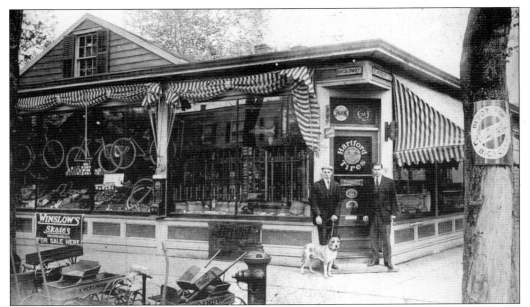

F. W. Diehl Jr. Sporting Goods c. 1920, 702 Broadway. In 1902 Frederick W. Diehl Jr. transformed his father's cigar store on the corner of Elmendorf Street into a sporting goods store. A 1905 full-page ad in the Kingston City Directory listed everything that was stocked from "A to Z." For example, "B" was baseballs and bats, "V" was velocipedes, and "W" was wagons and wheelbarrows. The man holding the dog's leash is Jacob A. Hummel Sr., Diehl's nephew.

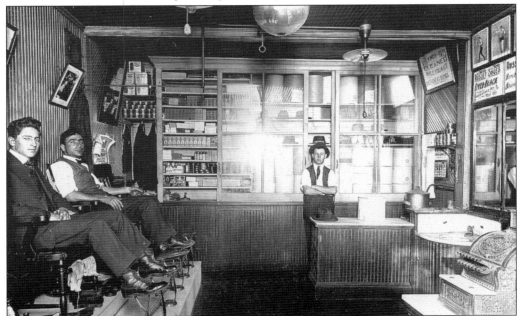

Joseph Erena Bootblack, c. 1914, 588 Broadway. Around 1910, Joseph Erena and his brother Ralph settled in Kingston and set up shop. Joseph was a bootblack and Ralph a shoemaker. The shop offered shoe shining and dyeing, hat blocking, and, as the sign says, "all kinds of hats cleaned while you wait." Joseph died in 1930.

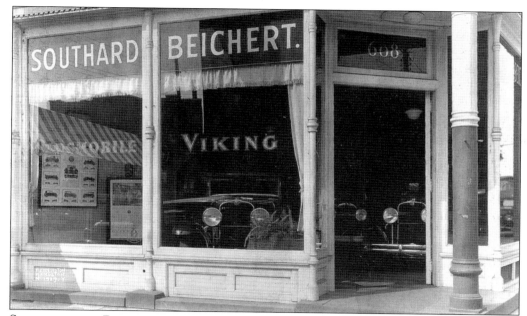

SOUTHARD AND BEICHERT AUTOMOBILES C. 1929, 608 BROADWAY. The firm of Monroe T. Southard and P. Joseph Beichert organized in 1923 to sell automobiles and operate Colonial City Cabs (located on Railroad Avenue). Among the first automobile dealers in the city, Southard and Beichert sold Liberty, Gardner, Oldsmobile, and Viking cars, as well as Stewart Motor Trucks. This is a portrait of their new showroom on the corner of Field Court.

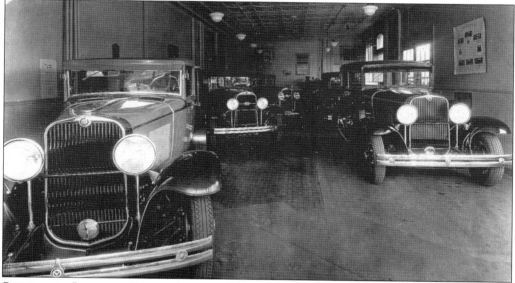

SHOWROOM INTERIOR SOUTHARD AND BEICHERT C. 1929, 608 BROADWAY. New Vikings and Oldsmobiles fill the showroom of Southard and Beichert. Beichert was also the radio operator for the basketball games held at the armory, which were broadcast from the city hall tower between 1924 and 1927. A runner would breathlessly dash back and forth across Broadway to deliver the scores. After the fire of 1927 destroyed the original tower—the highest spot in the city—the radio station closed.

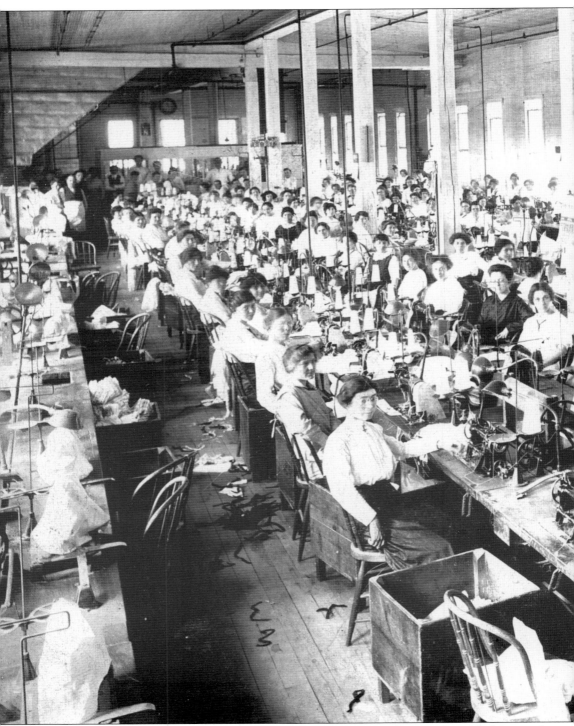

F. JACOBSON AND SONS C. 1920, 77 CORNELL STREET. On February 13, 1917, the new shirt manufactory of Jacobson and Sons had a formal opening. The company had factories in

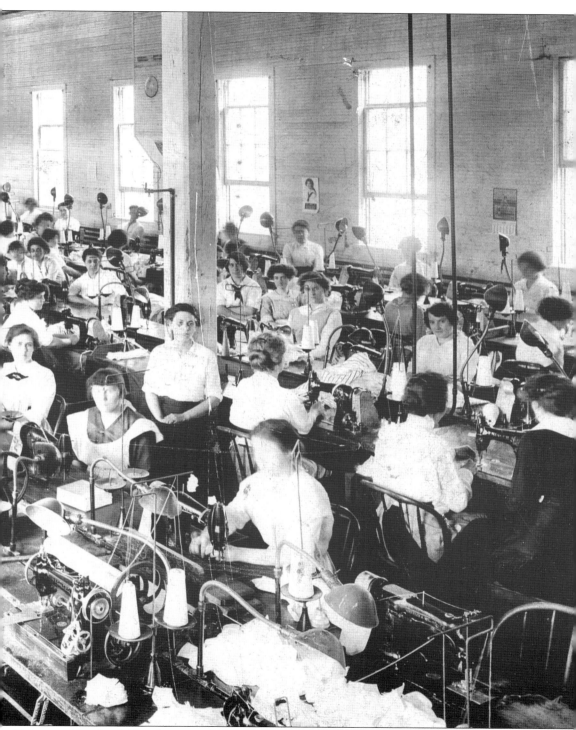

Delaware, Maryland, New Jersey, and New York. Max Charchian of Kingston was the manager of this plant. On this one floor, approximately 200 employees worked at their sewing machines.

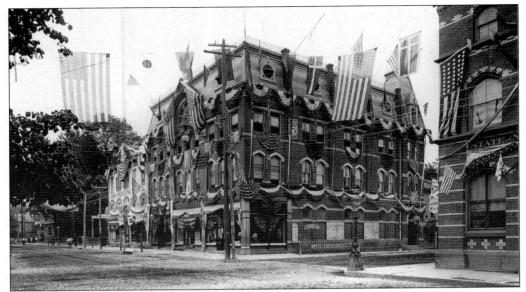

THE CLERMONT C. 1885, 295 WALL STREET. Abel A. Crosby was a local merchant with extensive real estate holdings when he built the Clermont about 1880. The top floor of the building was the lodge for the Knights of Pythias and featured painted murals on the ceiling. Oliver Brigham's Oyster Bay Restaurant occupied the basement. The building is decorated with flags and bunting for an unknown occasion.

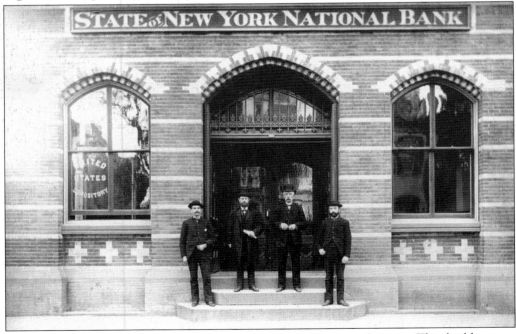

STATE OF NEW YORK NATIONAL BANK C. 1890, 301 WALL STREET. This building was erected in 1865 by the First National Bank of Kingston on the corner of John Street. In 1869 it merged with the State of New York National Bank, which had formed in 1853. In 1959 it was acquired by the National Ulster County Bank, which was located across the street.

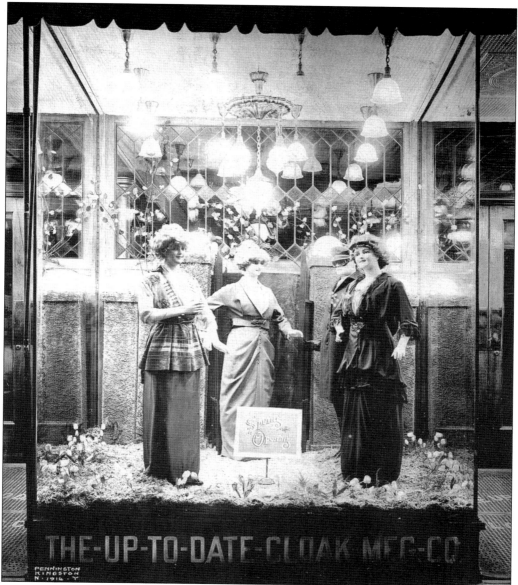

THE UP-TO-DATE CLOAK MFG. CO, C. 1914, 305 WALL STREET. The sign in the showroom window gives notice of the store's 1914 "Spring Opening." Company president Frank Forman was the foremost promoter on Wall Street at this time, and he was instrumental in bringing in stores such as Whelan Drugs, Kinney Shoes, J. J. Newberry, and Grant's Five and Dime. He also initiated the project to move St. John's Episcopal Church from Wall Street to Albany Avenue, stone by stone. The former church site became a theater.

HYMAN REUBEN, TAILOR C. 1914, 589 BROADWAY. This photograph of Hyman Reuben and his daughter Jane was probably taken shortly after Reuben opened his tailor shop on Broadway. Several of his family members were employed at F. Jacobson's Shirt Factory. Reuben's son Isaac became an architect in Washington, D.C.

MRS. HENRY R. LEEDER, MILLINER C. 1914, 658 BROADWAY. A typical millinery shop in Kingston prior to World War I was that of Mrs. Leeder, seen here standing at the left, showing off one of her hats for the camera. The two young women on the right are unidentified. The Kingston City Directory of 1916 lists 15 "milliners and millinery goods" in addition to Mrs. Leeder, whose shop closed in 1926.

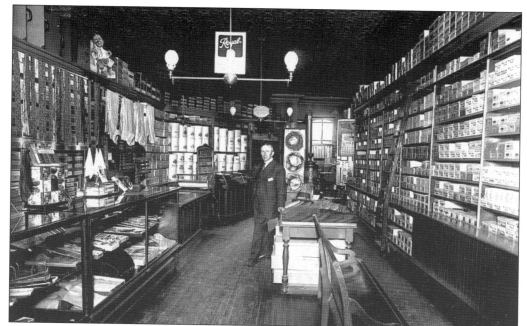

EDWARD S. POLLEY SHOES AND MEN'S FURNISHINGS C. 1914, 561 BROADWAY. The owner stands amid his stock of shirts, hatboxes, and shoes. Mr. Polley opened his establishment in 1905 at age 35, and spent his entire career on Broadway until his retirement in 1942. He died on March 6, 1948.

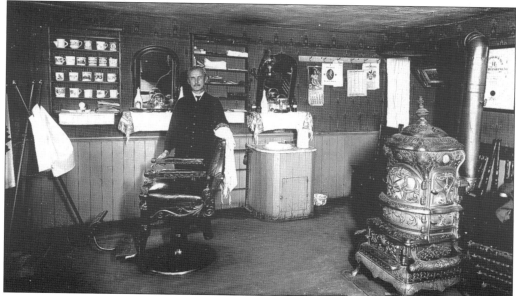

MANSION HOUSE BARBER SHOP C. 1914, 9 BROADWAY AT WEST STRAND. Casper Lowerhouse awaits another customer at his popular barber shop on the ground floor of the Mansion House. A rack of personal shaving mugs waits for the regular customers, a political advertisement announces that Sheriff Edgar T. Shultis is seeking another term in office, and the monumental coal stove will keep visitors warm. The calendar on the wall tells that the date is October 1914.

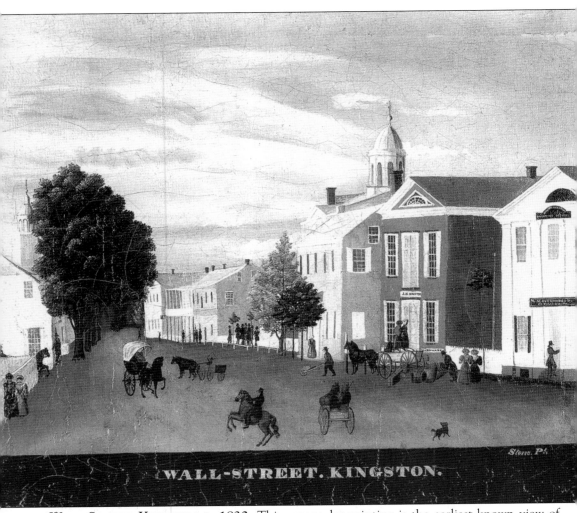

WALL-STREET. KINGSTON.

WALL STREET, KINGSTON C. 1832. This vernacular painting is the earliest-known view of Wall Street. It depicts the courthouse in the foreground, the John Sudam House (Fred J. Johnston Museum) at the corner of Main and Wall Streets, and the steeple of the Old Dutch Church behind the trees on the left. This was the main business block in uptown Kingston.

Seven

STREET SCENES

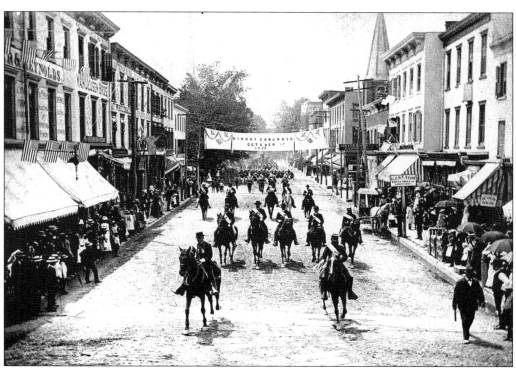

WALL STREET, BURNING OF KINGSTON CENTENNIAL PARADE, 1877. The city commemorates the 100th anniversary of the burning of the village by the British on October 16, 1777. During the conflagration in 1777, more than 100 homes and businesses were destroyed and the inhabitants forced to flee.

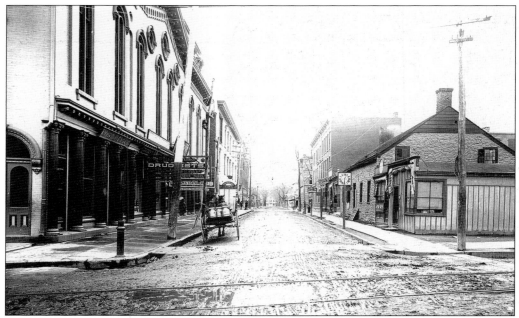

JOHN STREET C. 1880, FROM FAIR LOOKING TOWARD WALL STREET. In the 1880s, horsecar tracks ran down Fair Street. The Kingston Opera House was on the second floor of the building on the left. The noted actress Sarah Bernhardt and the poet Oliver Wendell Holmes were among the notables who appeared here. The post office was on the first floor, and next door was a drugstore that dispensed paint, oil, and varnishes, as well as prescriptions.

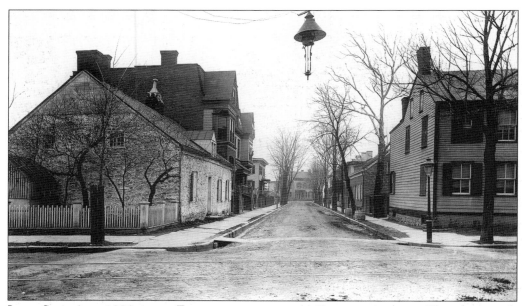

JOHN STREET C. 1880, FROM FAIR LOOKING TOWARD CLINTON AVENUE. This photograph looks at the streetscape in the opposite direction from the previous photograph. The 18th-century stone Joseph Chipp House on the left was later destroyed, but the adjacent double-gabled Queen Anne building still exists.

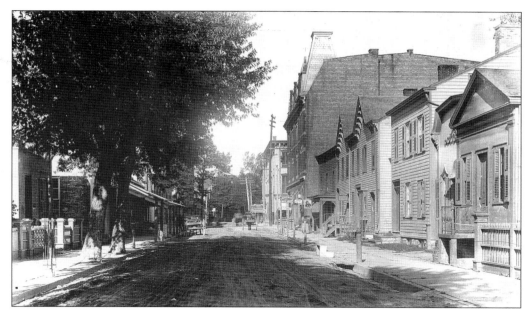

JOHN STREET C. 1880, FROM CROWN STREET LOOKING TOWARD WALL STREET. In the 1880s, the frame dwellings on the right stood where the Ulster County parking lot is now. The large, turreted Clermont building is still on the southwest corner of Wall Street. The large canopy over the sidewalk on the left is reminiscent of the Pike Plan on Wall Street today.

WALL STREET C. 1880, OPPOSITE ULSTER COUNTY COURTHOUSE. These small, wood-frame-and-brick one-story shops, occupied by an insurance company and Van Keuren's Washington Market, were soon replaced with large, commercial, Victorian-style buildings.

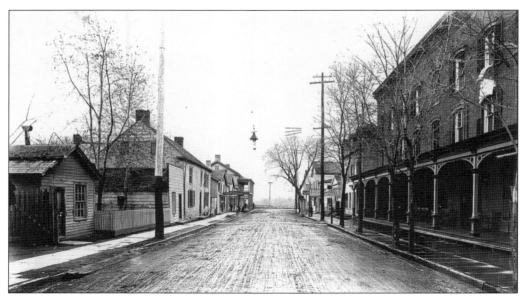

MAIN STREET C. 1880, FROM FAIR STREET LOOKING TOWARD CLINTON AVENUE. The stone house on the left was the Bank House, Kingston's earliest financial institution. The Eagle Hotel on the right (site of the current Ulster County office building and parking lot) was noted for its cuisine, but during early-morning hours bedclothes could be seen airing from an upstairs window.

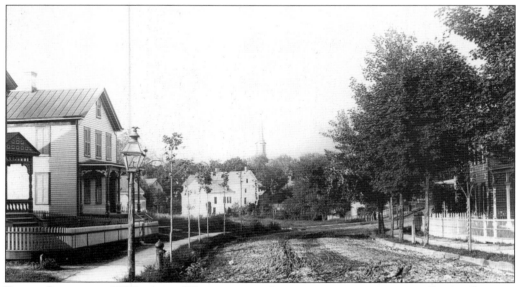

PEARL STREET C. 1880, FROM WASHINGTON AVENUE LOOKING TOWARD GREEN STREET. This photograph shows the unpaved roadway and gas streetlights of the period. Note the Old Dutch Church steeple in the distance.

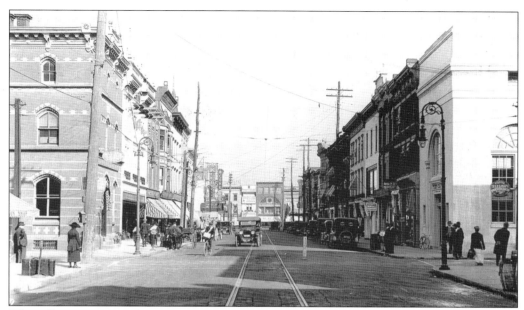

WALL STREET C. 1905, LOOKING NORTH FROM CORNER OF JOHN STREET. The city's first electric trolley car company, the Kingston City Electric Railway Company, was started in 1892, and the first automobile was driven on Kingston streets in 1900. According to a newspaper account, when the first illegally parked auto was noticed on Wall Street, no one in the crowd that gathered knew how to move it until the owner appeared.

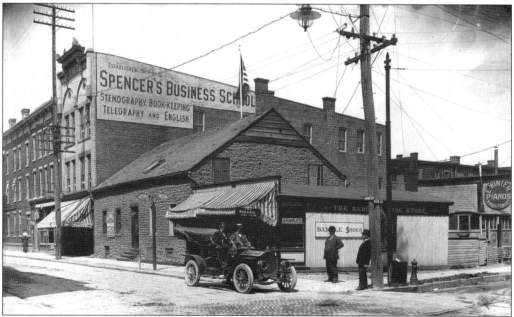

JOHN STREET C. 1910, CORNER OF FAIR STREET. Shortly after this photograph was taken, the Oke Sudam stone house on the right was torn down for the construction of the Stuyvesant Hotel. This house was the birthplace of John Sudam (1782–1835), state senator. Note that paving blocks have been installed on the roadbed since the 1880s view.

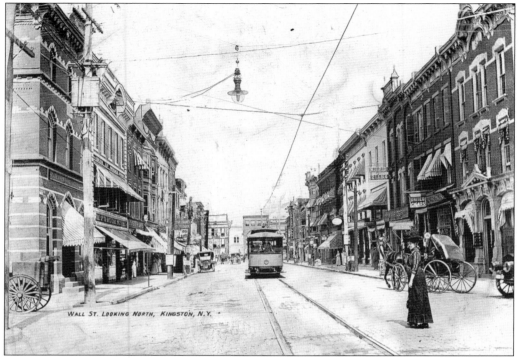

WALL STREET C. 1919, LOOKING NORTH. The Uptown Business District was thriving with a variety of stores offering everything from pianos to cigars; Keeney's Theater; and several five-and-dime stores. Modes of transportation ranged from the old-fashioned horse-drawn carriage to electric trolleys and the automobile.

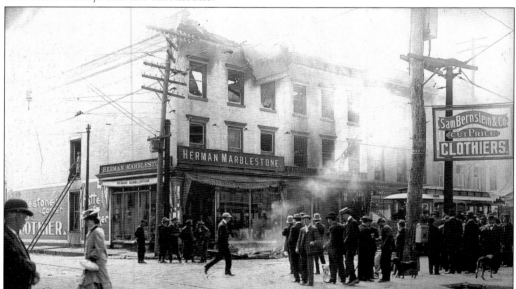

NORTH FRONT STREET C. 1918. This dramatic view depicts a fire at the corner of Wall and North Front Streets. The blaze transformed the business of Herman Marblestone, Clothier, into rubble.

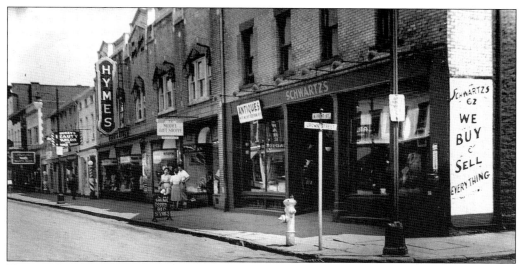

NORTH FRONT STREET, CORNER OF CROWN STREET, C. 1953. A series of well-established shops along North Front Street included Irving Schwartz's Antiques, Julius Sippen's Model Gift Shoppe, Hymes Men Furnishings, and the very popular Mickey Mazzuca's Beauty Parlor.

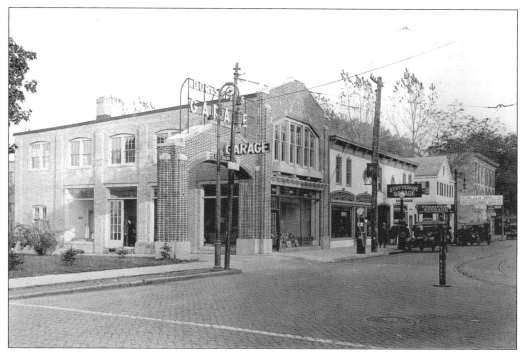

CLINTON AVENUE, CORNER OF MAIN STREET, C. 1920. About 1920, Dr. Wright J. Smith, a veterinarian, built this showroom with a decorative arch as an entrance to his automobile service, Doc Smith's Garage. There were apartments above and a storage garage behind it. The Stuyvesant Garage, located next door, was his competitor, and the Kirkland Hotel was directly across the street.

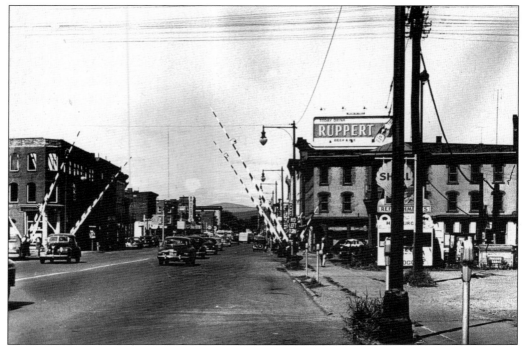

BROADWAY WEST SHORE RAILROAD CROSSING, C. AUGUST 1949. Shortly after this photograph was taken, work began on the underpass to build a roadway under the railroad crossing so cars would no longer be delayed by passing trains. The nearby buildings were demolished, including the former United States Hotel on the left and the Hotel Ulster on the right. The Herman O. Dietz Snack Bar, affectionately known as the White Pig, is seen on the right, and further up the street is the Broadway Theater marquee.

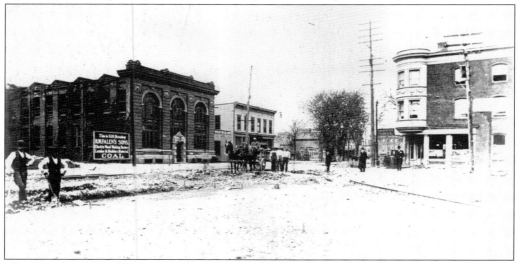

MIDTOWN C. 1907. Workers are laying paving bricks in front of the former United States post office. The H. W. Palen's Sons Woodworking Factory was demolished to make way for the Kingston YMCA. The building at the right has been totally altered to serve as a bank and, most recently, as medical offices.

PINE GROVE AVENUE C. 1911. As early as 1850 this was the entranceway to Wiltwyck Cemetery. The street to the right was named Pine Grove Avenue, the center walkway was privately owned, and the street on the left was named Terrance Avenue. In 1911, the property owners approved the plan to make it a boulevard called Pine Grove Avenue, with trees, benches, and sidewalks in the center. The two children sitting by the roadside are unidentified.

BROADWAY NEAR DELAWARE AVENUE C. 1893. The frame dwellings seen here were demolished for the current Rondout Savings Bank. The house on the right, built *c.* 1890, was the residence and office of prominent merchant Edward T. McGill. His brick building behind the house has recently been renovated for bank offices. Aaron Hymes, hatter at 29 Broadway, and Solomon Hymes, dealer in boots and shoes at 14 Broadway, resided in the two center homes in the 1890s.

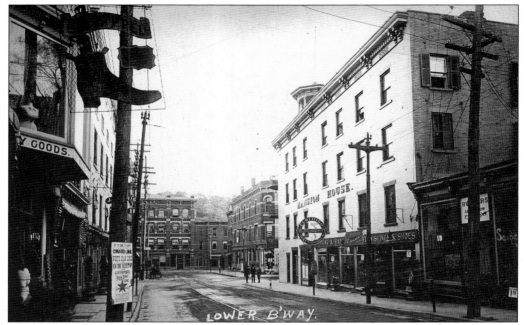

LOWER BROADWAY, LOOKING TOWARD STRAND C. 1890. Business was thriving at Rondout at the turn of the century. The Mansion House Hotel at the right and the Sampson Building across the street still stand, while the distinctive Cornell Steamboat Company office building at the foot of Broadway has been demolished. Note the fanciful sign on the left for Sol Appel's Shoes, Slippers, and Boots.

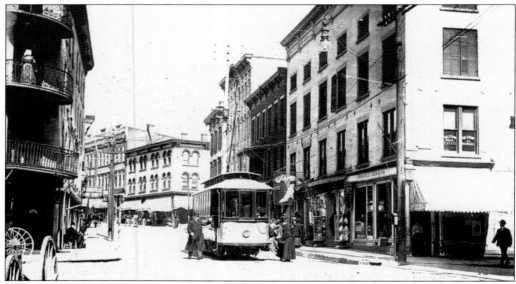

BROADWAY AT STRAND C. 1900. This photograph looks at the streetscape in the opposite direction from the previous image, with the Mansion House on the left. Two electric trolley companies vied for passengers from Kingston Point to Uptown. This car is bound for the Rhinebeck Ferry slip on East Strand. Connelly's Drug, which later became the very popular M. Yallum's Shoe Store, is on the far right.

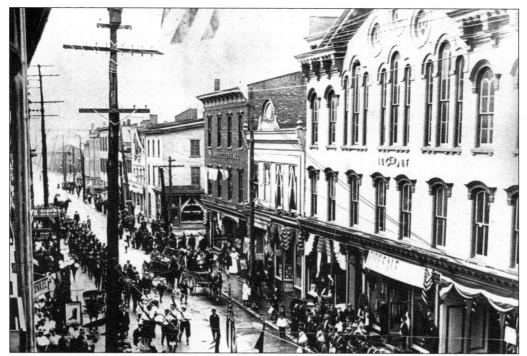

EAST STRAND C. 1880. This parade scene is unidentified. The building at the right held meetings for the Independent Order of Odd Fellows. The block was destroyed as part of urban renewal in the 1960s. Today this is the area where the Judge John Loughran Bridge crosses the Rondout Creek.

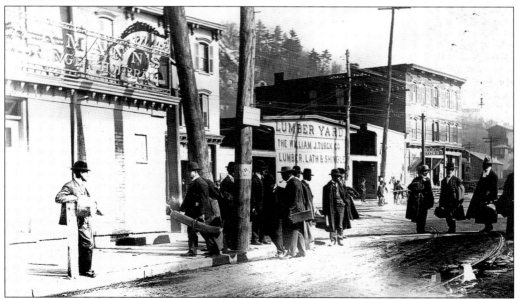

STRAND AND FERRY STREET C. 1900. The William J. Turck Company, seen at center, advertised in the 1900 city directory: "Yellow Pine Lumber, the largest dealers on the Hudson River, Rondout NY." The musicians standing in front of the lumber yard are unidentified.

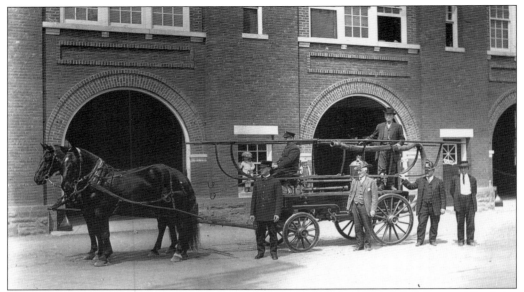

HAND PUMPER C. 1908, CENTRAL FIRE STATION, 19 EAST O'REILLY STREET. All of the regular firefighting machines have been brought out for a parade. The hand pumper, already an antique when the photograph was taken, probably dates to the mid-1800s, before the development of the horse-drawn steam engine.

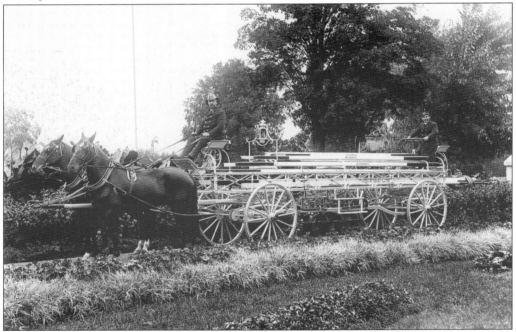

FIRE LADDER TRUCK C. 1880, BURGEVIN FLORISTS, 222 PEARL STREET. This early firefighting ladder truck is shown on the grounds of Burgevin Florists, which maintained many greenhouses and extensive landscaped grounds on upper Pearl Street until the mid-1960s. Since Kingston had not developed its many parks yet, the city fathers used this beautiful park setting to show off the new ladder truck.

Eight

CITY LIFE

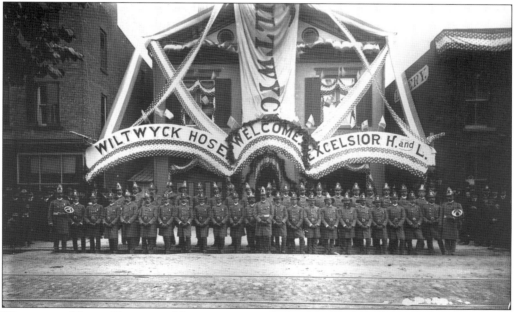

WILTWYCK HOSE COMPANY NO. 1 C. 1882, 267 FAIR STREET. Perhaps a firemen's convention or a parade is the reason all these volunteer firemen are dressed in full regalia. With the construction of the Central Fire Station on East O'Reilly Street in 1906, the city of Kingston established a paid fire department. The Excelsior Hook and Ladder Company lost its headquarters on Crown Street to a fire in 1882, and rebuilt on Hurley Avenue in 1883.

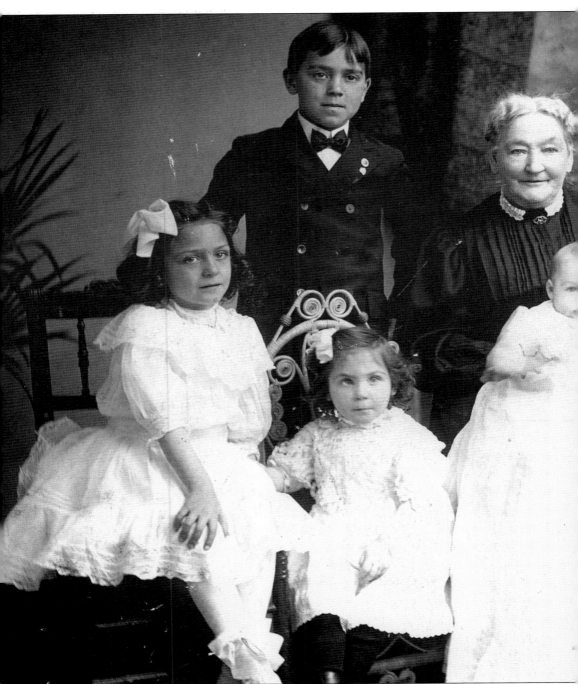

DERRENBACHER FAMILY PORTRAIT C. 1910. John Derrenbacher, born in Prussia, came to America in 1834 and settled in Rondout. He married Margaret Fox Derrenbacher, shown here surrounded by her great-grandchildren. The children's names are, clockwise beginning with the child to the right of Mrs. Derrenbacher, as follows: Antoinette and Henry Ketterer; Joseph and Honey Koenig; Marie and Trude Beichert; Rita, Marie, and Kate Ketterer; and P. J. Beichert.

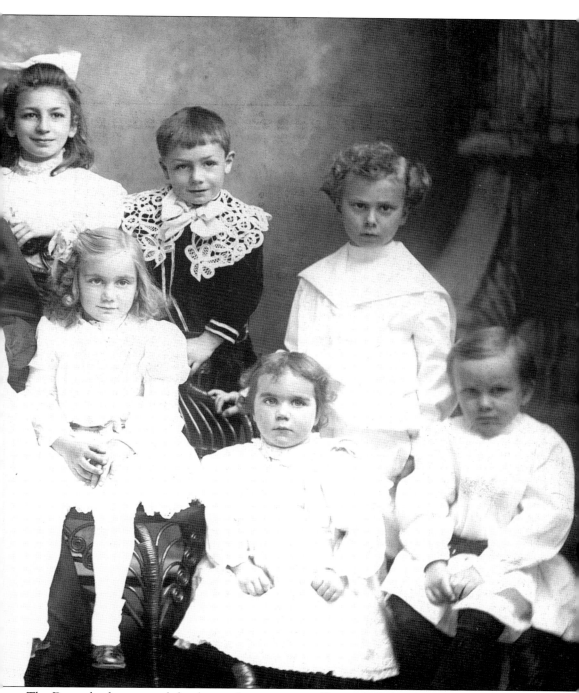

The Derrenbachers owned the dry goods store next to Ketterer's Delicatessen on Abeel Street, Rondout. The grandchildren all established successful businesses in Kingston, and descendants still live there. Joseph Koenig's son Frank served as mayor from 1970 to 1979, longer than any other mayor in Kingston history.

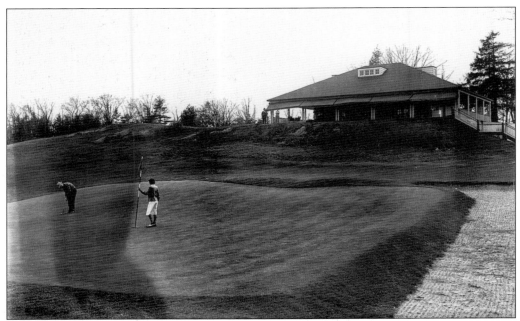

TWAALFSKILL GOLF CLUB C. 1940, 250 WEST O'REILLY STREET. Organized in 1902, the golf course formally opened in 1903 and was considered the finest on the Hudson River. The 34-acre site was leased from Kingston business mogul Samuel D. Coykendall. The original clubhouse, built in 1904, burned in 1925, and in 1927 this clubhouse was erected.

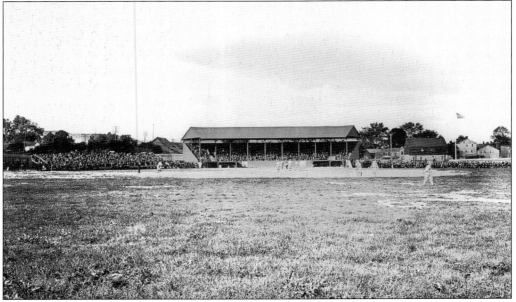

DIETZ STADIUM C. 1940, 170 NORTH FRONT STREET. In 1921 the Kingston Fair Grounds were developed, and the grandstand pictured here was built in 1924. The new stadium generated interest in the game of baseball. Babe Ruth played a game here in 1926 and Joe DiMaggio in 1949. The stadium was renamed in honor of Staff Sergeant Robert H. Dietz, Kingston's only Congressional Medal of Honor recipient, who was killed in action in World War II.

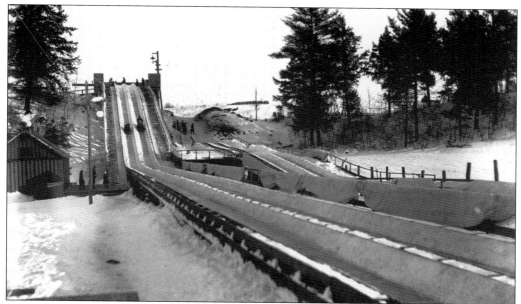

TOBOGGAN SLIDE C. 1890, MARY'S AVENUE AND ANDREW STREET. A double toboggan slide was constructed here by a private consortium that included Samuel D. Coykendall. The tracks were lined with cakes of ice, and the smooth sides made steering unnecessary. At the left, the clubhouse provided warmth in between runs. After the ride on one side, climbing the opposite hill provided a ride back.

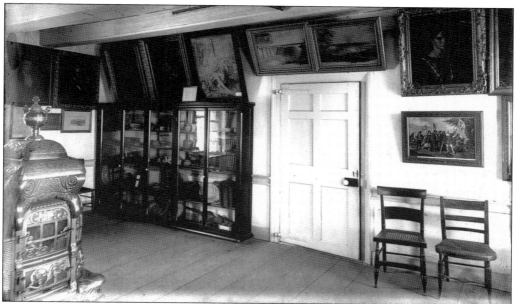

SENATE HOUSE INTERIOR C. 1900, 331 CLINTON AVENUE. New York State acquired the 1676 Senate House in 1887 and for many years, displayed local artifacts of many periods in its rooms. In the 1960s, the house and its collections were rearranged to interpret the period during the American Revolution when the newly formed New York state senate met in the house in the fall of 1777. All other artifacts were removed to the Senate House Museum that was built in 1927.

BILL, KINGSTON OPERA HOUSE, 285 FAIR STREET, 1891. This theatrical bill from January 19–20, 1891, announces the grand opening of the opera house with a double bill. Erected by John H. Cordts on the corner of Fair and John Streets, the theater featured many favorites of the day, including Maurice Barrymore, boxer James Corbett, and poet Oliver Wendell Holmes.

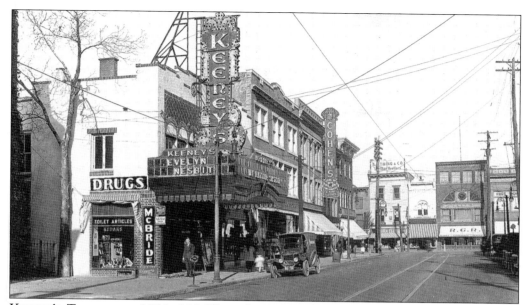

KEENEY'S THEATRE C. 1921, 325 WALL STREET. Built in 1919, this theater was owned by Frank Keeney of Brooklyn, New York. Later it came under the management of Walter Reade. Vaudeville acts supplanted the early silent motion pictures that were accompanied by an orchestra playing in the pit. The marquee here features Evelyn Nesbit in the film *My Little Sister*. George Muller's orchestra played between features. Tickets cost 28¢. The theater was extended back to Crown Street in 1926.

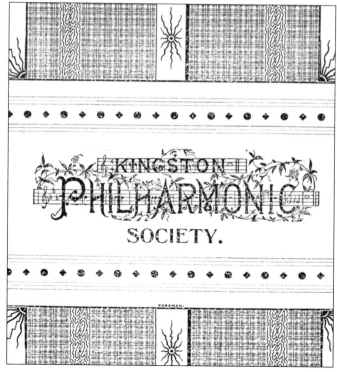

KINGSTON PHILHARMONIC SOCIETY PROGRAM, MAY 18, 1892. Founded in 1888, this organization was devoted to the study of high-quality choral music. Some of the most celebrated vocalists, instrumentalists, and orchestras were engaged at great expense. Samuel D. Coykendall was the president and financial sponsor, but due to a lack of support, the society ceased operations in 1895.

115

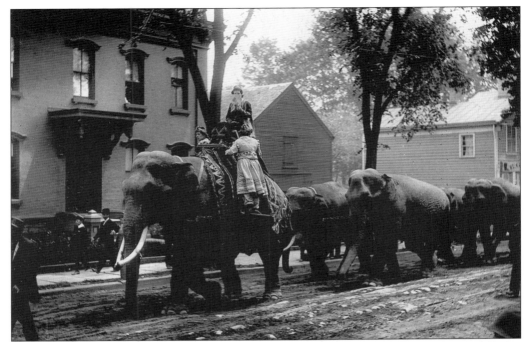

BARNUM AND BAILEY CIRCUS ON WALL STREET, MAY 23, 1893. The Barnum and Bailey Circus, billed as "the Greatest Show on Earth," came to Kingston in 1893, arriving in four sections on 64 West Shore Railroad cars. The circus boasted a stage measuring 400 feet long and a canvas tent that was 550 feet long. The elephants, in addition to parading through the streets, were used to help put up the huge tent poles and canvas.

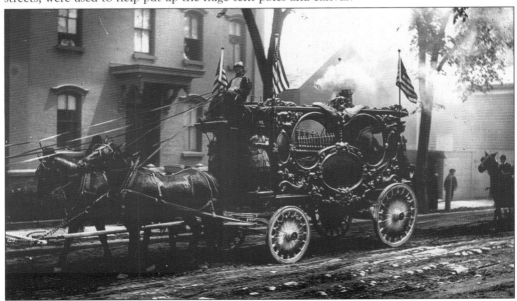

BARNUM AND BAILEY CIRCUS ON WALL STREET, MAY 23, 1893. The steam calliope passes by the building known today as St. Joseph's Church Rectory. When steam was forced through a series of whistles, it produced the type of melody we associate with the circus.

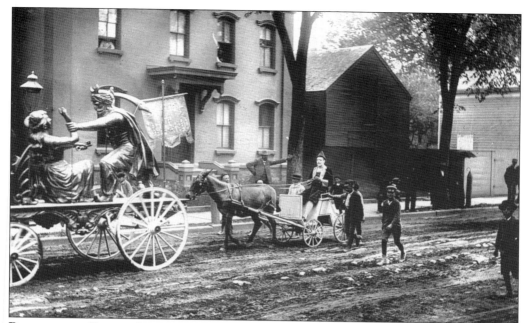

BARNUM AND BAILEY CIRCUS ON WALL STREET, MAY 23, 1893. The circus parade had 100 golden chariots and historical floats. Seen on the left is a representation of the pirate Bluebeard as he threatens his seventh wife, Fatima, for yielding to curiosity and unlocking a door behind which she discovers the bodies of her predecessors. The theme of the small carriage at the right may be the nursery rhyme "Little Jack Horner."

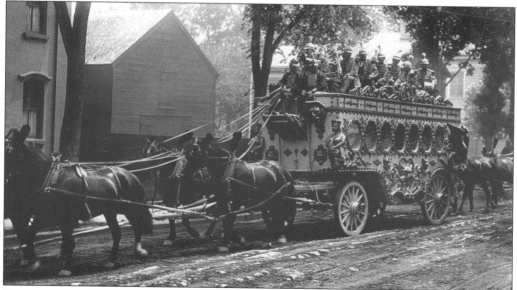

BARNUM AND BAILEY CIRCUS ON WALL STREET, MAY 23, 1893. Riding on the gaily decorated bandwagon, the circus band was an important feature of every circus, playing lively music for all the acts. Two performances were offered in the one-day show. Tickets cost 50¢ for adults and 25¢ for children under nine. Twenty years later, a circus brought Annie Oakley and Buffalo Bill Cody to Kingston.

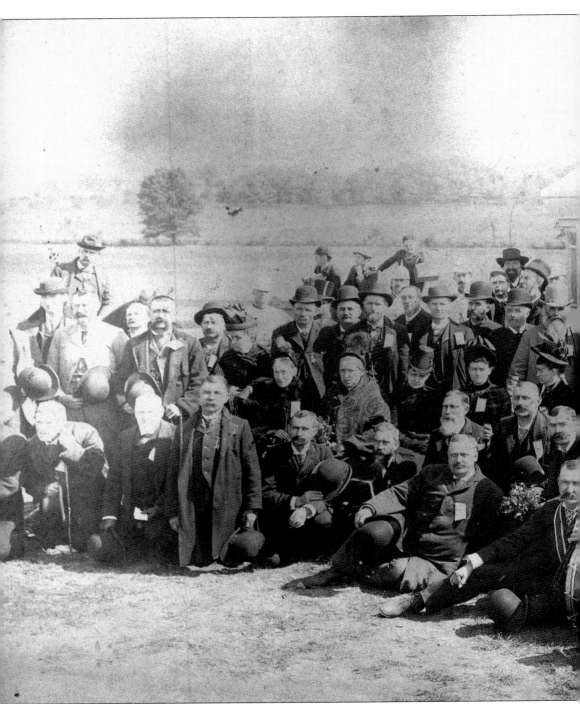

CIVIL WAR MONUMENT AT GETTYSBURG, PENNSYLVANIA, OCTOBER 4, 1888. On this date, Ulster County Civil War veterans met at the Gettysburg battlefield to dedicate this monument, which reads: "Ulster Guard 20th N.Y. State Militia and 80th N.Y. Infantry 1st Brigade 3rd Div 1st Corps/Organized 1851, Kingston N.Y." This referred to the militia regiment that left

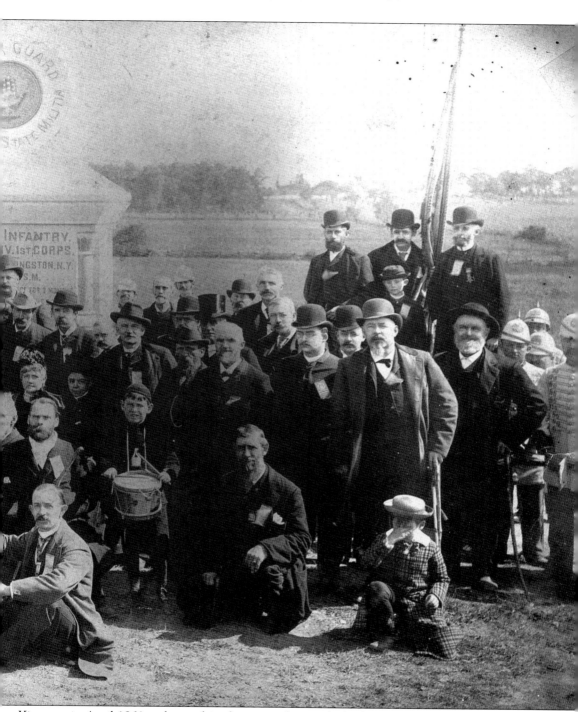

Kingston in April 1861 and served its three-month period of enlistment in the Baltimore area. When the regiment returned, it was reorganized for three years' service as the 80th Regiment New York State Volunteers, popularly known as the Ulster Guard. The regiment earned 13 battle honors, which included Second Bull Run, Antietam, Fredericksburg, and Gettysburg.

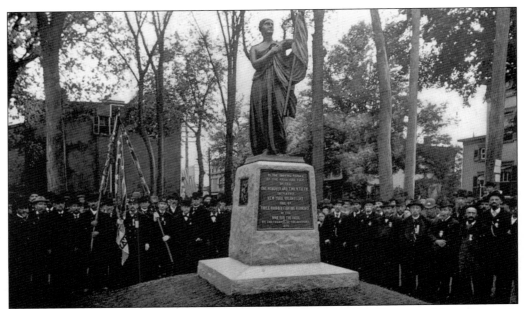

SHARPE CIVIL WAR MONUMENT, OCTOBER 17, 1896, CORNER OF FAIR AND MAIN STREETS. Maj. Gen. George H. Sharpe dedicated this monument to the men of his regiment, the 120th, and it is the only known monument erected by a general to honor his men. The statue, titled "Patriotism, Daughter of the Regiment," was unveiled on October 17, 1896, in the Old Dutch Churchyard. At left, the tripod holds the battle flag that the regiment carried during the Civil War. Today the flag is preserved in a case in the narthex of the church.

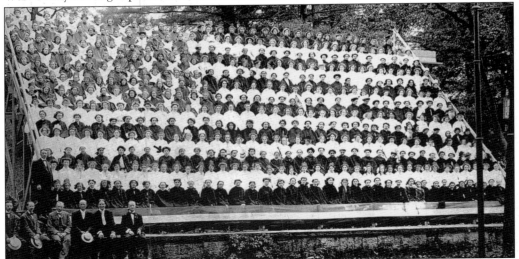

KINGSTON'S 250TH COMMEMORATION, MAY 30, 1908. A three-day celebration marked the 250 years since 1658 when the early European settlers moved to a stockaded area, now uptown Kingston, to form a protected settlement. Benjamin Myer Brink, author of *Olde Ulster*, chaired the celebration that featured the return of the remains of New York State's first governor, George Clinton, from Washington, D.C., for interment in the Old Dutch Churchyard. A large stand was erected at city hall, where 500 young ladies dressed in red, white, and blue capes formed the flag pictured.

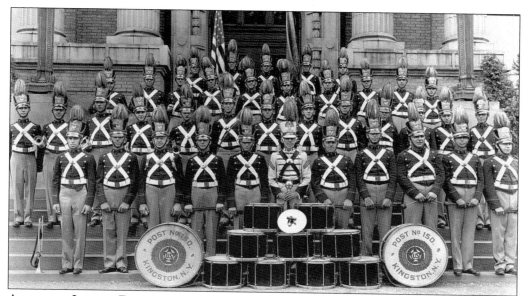

American Legion Drum Corps Parade Day, August 31, 1933. In 1926, the Kingston Post No. 150 formed the drum corps. Popular because of their precision marching and smart military cadet uniforms, they were much in demand for local events, and the money they earned enabled them to afford to travel to state and national legion conventions. At first the corps was composed of only post members, but later outside musicians were allowed to join. The corps disbanded in 1941.

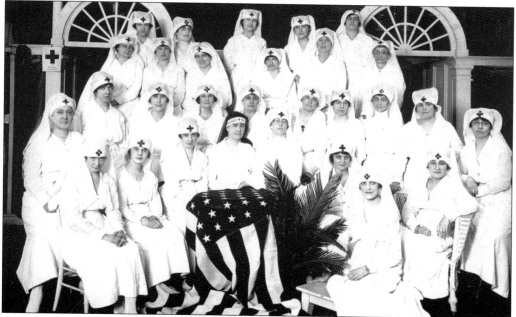

Red Cross Workers, May 23, 1918. These ladies, all employed as sales clerks and office personnel at the L. B. Van Wagenen Company, 311 Wall Street, were Red Cross volunteers during World War I. Interestingly, one of them preserved this photograph and recorded all their names, marriages, and deaths on the back.

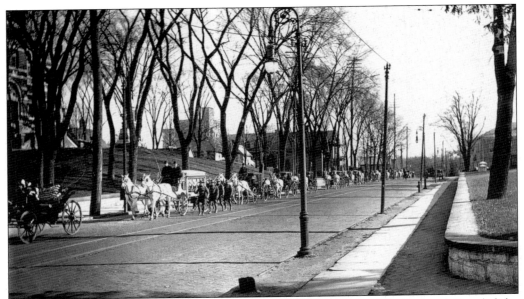

FUNERAL ON BROADWAY, JANUARY 13, 1913. The death of Samuel D. Coykendall ended the career of one of the most influential industrialists in Kingston's history. The son-in-law of Thomas Cornell, he took over his father-in-law's business enterprises after Cornell's death in 1890. Coykendall was involved in railroads, steamboats, banks, trolleys, cement, bluestone, a newspaper, and real estate. He aided schools, churches, the library, cemetery, Twaalfskill Golf Club, and the toboggan slide, and was a member of many clubs and committees.

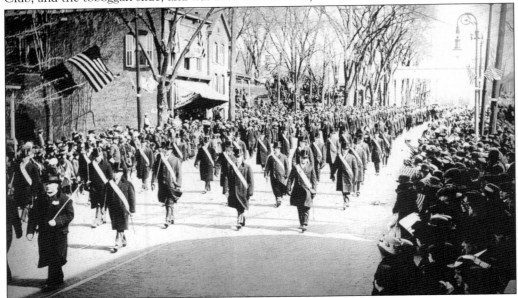

PARADE ON BROADWAY, APRIL 1, 1919. On this day, 60,000 people came from all over Ulster County to welcome our servicemen home from World War I. The parade began at the foot of Broadway, continued up the hill and through the wooden memorial arch in front of city hall to uptown, then back to the armory on Broadway for patriotic services. A bronze plaque in memory of the city's World War I veterans stands where the arch once was.

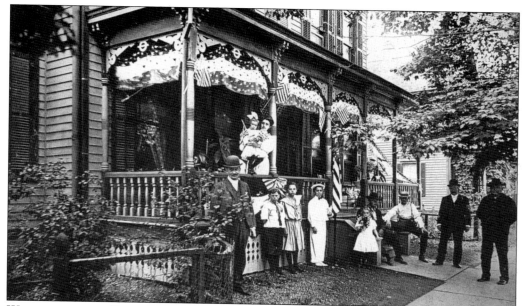

WAITING FOR THE PARADE C. 1910, 214 O'NEIL STREET. The patriotic Beichert family is set for a parade at their home on the corner of O'Neil Street and Foxhall Avenue. Joseph Beichert is shown here with his sons Joseph and J. Philip and their families, three generations ready to celebrate the holiday.

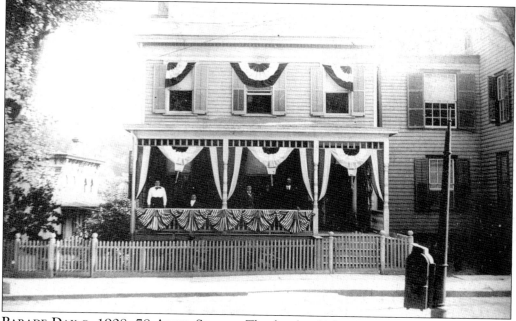

PARADE DAY C. 1908, 78 ABEEL STREET. The family of Max Wetterhahn is also ready for a parade at their home at the bottom of Wurts Street. The Wetterhahns arrived in Rondout by 1871 and established a grocery store on Abeel Street. When the long-awaited bridge across the Rondout Creek became a reality in 1921, the Wetterhahn house was destroyed to make way for the bridge.

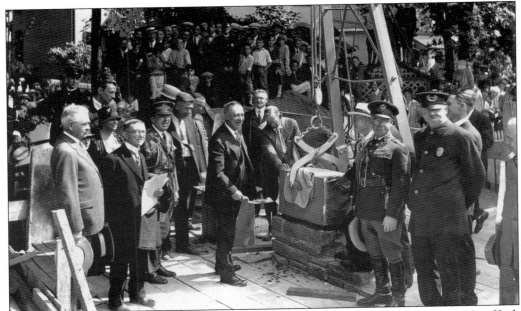

LAYING OF THE RONDOUT CREEK BRIDGE CORNERSTONE, SEPTEMBER 18, 1920. New York State governor Alfred E. Smith officiated at the laying of the cornerstone for the new bridge and 1,500 spectators attended the ceremony. Following lunch at the Eagle Hotel, the Automobile Club of New York returned to Wurts Street, where local newspapers, a city directory, and other artifacts were encased in the cornerstone. Judge Aphonso T. Clearwater stands on the left.

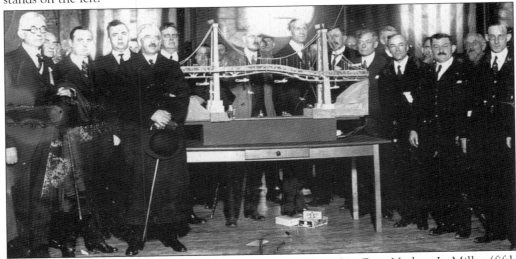

RONDOUT CREEK BRIDGE DEDICATION, NOVEMBER 29, 1921. Gov. Nathan L. Miller (fifth from left) and city officials stand beside a model of the new bridge displayed at a luncheon at the New York State Armory, 467 Broadway. The model was built by Isaiah Ginzburg, a Rondout druggist. An estimated 10,000 people walked across the nearly completed bridge following a large parade from the armory to lower Wurts Street. A press release said motorists would find the $700,000 structure that spanned the last gap in New York State a vast improvement on the route to Kingston, the Catskills, the Ashokan Reservoir, Buffalo, and the West.

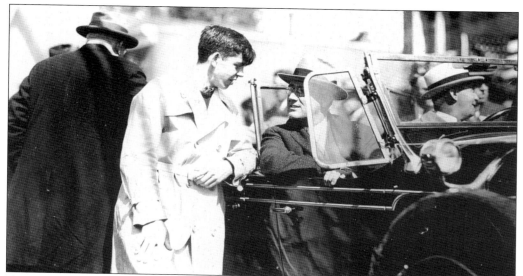

FRANKLIN DELANO ROOSEVELT AT ACADEMY GREEN C. 1932. Franklin D. Roosevelt always included a visit to Kingston in his campaign schedule. In a letter from Hyde Park, dated November 9, 1940, he wrote: "Dear Friend, the greatest happiness that election day brought to me was the news that you, my neighbor, supported me with your vote. No matter how great the pressure of national and international affairs, I have had constant inspiration from the friendships back home. Your neighbor, FDR."

ELEANOR ROOSEVELT WITH QUEEN JULIANA, APRIL 5, 1952, MUNICIPAL AUDITORIUM, 467 BROADWAY. Eleanor Roosevelt greeted Queen Juliana of the Netherlands during Kingston's tercentenary celebration. More than 2,000 spectators enthusiastically welcomed the queen (in white coat with fur wrap). John Roosevelt, son of Eleanor and FDR, stands at left on the stage. Following the speeches, the queen went to the Academy Green to lay a wreath at the monument of Peter Stuyvesant and proceeded on to the Old Dutch Church for a reception.

HUDSON-CHAMPLAIN CELEBRATION 1609–1959, JUNE 5, 1959. On Kingston's Academy Green, beneath the statue of Peter Stuyvesant, this group reenacts the signing of the Treaty of Peace between the early European settlers and the Esopus Indians. The treaty's signing on July 15, 1660, marked the end of the First Esopus War. The short-lived peace lasted for only three years.

PRINCESS BEATRIX HUDSON, HUDSON-CHAMPLAIN CELEBRATION, SEPTEMBER 18, 1959. As part of the celebration, Princess Beatrix of the Netherlands visited Kingston and laid a wreath at the statue of Henry Hudson, who had been employed by Dutch merchants when he discovered the river that bears his name in 1609. At the microphone is Albert C. Kurdt, chair of the celebration, and seated from left to right are Mayor Edwin Radel, Mrs. Beatrice Radel, Harry Rigby, Princess Beatrix, and State Senator and Mrs. Ernest Hatfield.

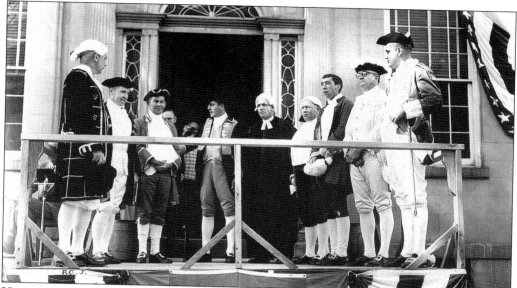

HUDSON-CHAMPLAIN CELEBRATION, ULSTER COUNTY COURTHOUSE STEPS, SEPTEMBER 12, 1959. This was "Empire State Day" commemorating the 182nd anniversary of the forming of New York State's government in September 1777 as reenacted by members of the Ulster County Bar Association. Over the steps of the courthouse a platform was built on the exact spot where George Clinton was sworn in as the first governor on July 30, 1777. Attorney Howard C. St. John is third from the left and Reverend Arthur E. Oudemool of the Old Dutch Church is fifth from the left.

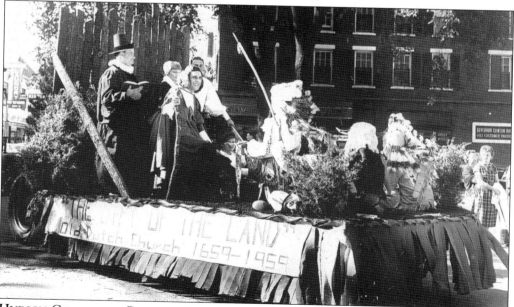

HUDSON-CHAMPLAIN CELEBRATION PARADE, SEPTEMBER 12, 1959. On this parade float titled "The Gift of The Land," seen at the corner of Albany and Clinton Avenues, parishioners of Old Dutch Church depict the Dutch farmers accepting the fertile farm land from the Esopus Indians. The backdrop is a replica of the 1658 stockade.

DOODLEDORFERS BAND C. 1935. This very popular musical group made up of Post No. 150 American Legion members was a hit every time they marched in a parade or at a public function. The band members are, from left to right, Harry Sills (bass drum), John Emmet (snare drum), Charles Lukaszewski (baritone), Steve Baliszewski (trumpet), Charles Lord (trumpet), and Henri Abramowitz (tuba).

MAY DAY C. 1924, KINGSTON HIGH SCHOOL. The celebration of May Day was carried over from Kingston and Ulster Academies to Kingston High School. The court consists of Prime Minister Edwin Messinger; May Queen Mary Butler; Maid of Honor Sally Davis; and attendants (alphabetically) Katherine Bennett, Henrietta Bruck, Gertrude Falvey, Harriet Frake, Marianina Gorham, Charlotte Jones, Helen Mitchell, and Kathryn Van Valkenburg. Youth springs eternal!